# Maker-Artists

*of*

# Milton Keynes

# Maker-Artists

## *of*

# Milton Keynes

LINDA WILKS & ANN PEGG

PHOTOGRAPHY BY BRIAN TOMLINSON

The
History
Press

First published 2017

The History Press
The Mill, Brimscombe Port
Stroud, Gloucestershire, GL5 2QG
www.thehistorypress.co.uk

British Library Cataloguing in Publication Data.
A catalogue record for this book is available from the British Library.

ISBN 978 0 7509 8115 6

Typesetting and origination by The History Press
Printed in Malta by Melita Press

# Contents

# Foreword by Boyd & Evans

One of the great things about being an artist is that you start each day engaging in activities, which, by definition, you consider important. There is a great deal of satisfaction to be found simply by doing, engaging in your chosen medium and seeing how this open-ended activity works out. Artists do this and if we're lucky we will get to see what they have found on their journeys. This book celebrates the journeys and activities of twenty-five of these creative people, all based in Milton Keynes.

We were invited to Milton Keynes to be artists-in-residence by the Development Corporation. We arrived on 1 January 1982, expecting to be here for a year; we are still here. The fact that Milton Keynes was a town that had a budget to purchase work and set up residences, that thought artists could add to the fabric of the development, was out of the ordinary.

Ever since Milton Keynes was designated a 'New Town' there has been a groundswell of people making their own artefacts, exhibitions and theatre. In its early days the Development Corporation supported them with community workshops and community spaces where plays, concerts and exhibitions could take place. After the Development Corporation closed in 1992, artists and activists were left to do more for themselves. And they did. There was the enormous annual summer exhibition by the Silbury Group and the late lamented Milton Keynes Craft Guild in the 1980s. Then Westbury Farm took over. Sitting Ducks were a group of young artists based around the MK Gallery. Continuing the drive are Festive Road, MK Arts Centre and Arts Central. The maker-artists in this book are part of this continuum.

Along with the many attempts at arts centres, galleries, sculpture walks and other ways to involve and include the arts in the lives of residents, thanks to lottery funding and tremendous enthusiasm and hard work we got a world-class gallery and theatre in 1999. This has made a huge difference to outside perceptions of Milton Keynes. What we still need for the arts to flourish here is an art school and a campus-type university, which would be, like the gallery and theatre, centres of excellence.

We hope that you will find the stories of the maker-artists in this book as inspiring as we do and that they will encourage you to explore and celebrate the creativity of Milton Keynes.

*Fionnuala Boyd and Les Evans*

## ABOUT BOYD & EVANS

The artists Boyd & Evans have lived in Milton Keynes since 1982 and work together to create painting, drawing and photographic imagery. They have shown their work nationally and internationally, including a major exhibition at the MK Gallery in 2005. A number of large-scale commissioned pieces can be seen across Milton Keynes, including *Fiction, Non-Fiction and Reference* and *Situation Comedy* in the Central Library. Their works are also on display in many public and private collections across the world, including at the Museum of Modern Art in New York and Tate Britain in London.

More information can be found on their website at: www.boydandevans.com

# Acknowledgements

We would like to thank the twenty-five maker-artists who agreed to be interviewed, photographed and written about for this book. They were all so generous with their time and their enthusiasm. Thank you also to the many other Milton Keynes-based artists who have shown interest in our project. We would have liked to have been able to include you all and you are all there in spirit.

Thank you to the planners and developers of Milton Keynes who have supported artistic endeavour across the city since its designation as a new town – long may it continue. Thank you also to the staff and volunteers at the city's artistic spaces, who do so much to encourage and facilitate the talent of local artists.

Thank you to Marion Hill for gathering together information for us about the history of art in Milton Keynes.

Thank you to Matilda Richards at The History Press for believing in this 'niche' book and to designer Jemma Cox for helping to shape it into a book, which celebrates the culture, place and people of Milton Keynes.

Finally, thank you to our families and friends for their feedback and encouragement.

*Linda Wilks, Ann Pegg and Brian Tomlinson*
*March 2017*

# Author and Photographer Biographies

### LINDA WILKS

Linda Wilks is interested in people and the ways in which they relate to art, music and festivals. She has worked for many years at the Open University in Milton Keynes and has lived in Olney for even longer. Linda has a PhD from the OU on the social and cultural value of festivals and has published books and articles on the arts. She enjoys printing, dyeing and sewing textiles as well as going to art galleries and music events.

### ANN PEGG

Ann has published articles and books for academic, workplace and craft community audiences. She has been a tutor and course writer for the Open University for many years. She is a musician and keen ceramics practitioner and is currently experimenting with earthenware clay and oxides to produce simple forms. She lives in Bletchley, Milton Keynes and is a volunteer at the Westbury Arts Centre.

### BRIAN TOMLINSON

Brian is a photographer and artist with a passion for nature and music. His work has been published in the world's biggest photo book at The Truman Gallery, on the BBC's *Sky at Night*, on album covers, on festival websites and in event programmes. He was commended in the 2016 Sony World Photography Awards. He is a life-long resident of Newport Pagnell, Milton Keynes and has a keen interest in the local music and arts scene. More of his work can be found at www.btprints.com.

# Introduction

As Milton Keynes celebrates its fiftieth birthday, this book delves into the lives and work of twenty-five makers of handcrafted artistic objects who are based there today. It explores how the landscape of Milton Keynes, from the recently built ultra-modern to the enduring pockets of historic buildings, stimulates and enhances the artistic lives of these makers.

The featured maker-artists have been chosen for the ways in which their use of the materials of ceramics, wood, metal, glass, textiles and stone, in the words of William Morris 'beautifies the familiar matters of the everyday'. The tactile and textured materials used by the present-day maker-artists of Milton Keynes are the same as those shaped by bygone artisans using traditional tools and techniques, highlighting their dynamic dialogue with the past.

The term maker-artist used in this book values the skills, traditions, imagination and creativity, which the individuals display. It emphasises the making process and hints at a functional use for the objects they make, whilst acknowledging that the beautiful three-dimensional forms they make are also definitely art.

Living in one the world's most successful New Towns, the maker-artists tell stories of how they have access to a wealth of inspiration to translate into their work. Milton Keynes' urban and rural environment of green spaces, lakes and canals, stunning new architecture and well-preserved medieval buildings have all helped to spark ideas.

*Westbury Arts Centre, located in a seventeenth-century Grade II-listed building.*

*Thoughts on a Bent Curve by Ekkehard Altenburger in Tongwell, installed in 2015 outside one of Milton Keynes' newest buildings.*

The maker-artists also highlight how their networks of local links to other artists help them to live their creative lives. Cultural spaces across the city, including the Westbury Arts Centre, Milton Keynes Arts Centre at its two sites, Great Linford and Galley Hill, and the Arts Central studios at Norfolk House and Clyde House, provide the settings in which they have formed communities where creative energy is generated, as well as skills shared and developed. The biennial IF: Milton Keynes International Festival and its associated Fringe:MK, the annual Bucks Open Studios and the newly developed Milton Keynes Arts Week are cultural events, which encourage Milton Keynes-based maker-artists to present their work and intensify the creative vibe of the city. Also providing support, the Arts & Heritage Alliance Milton Keynes (AHA-MK) is a forum of thirty-six organisations that work together to position the arts and heritage sectors as contributors to the community and economy of Milton Keynes.

As well as discussing the materials, tools and techniques that they use, the maker-artists explain how their creative activity fits into their lives. They tell of the emotional rewards of making, explaining how the rhythm of problem finding and problem solving helps them to develop their skills and results in satisfaction with both the process of making and with the finished outcome. Many of the maker-artists discuss running their own micro-enterprises, selling their handmade objects online, at craft fairs, through exhibitions or via galleries. Many also describe sharing their skills with students in local schools and colleges or with adult learners and community groups.

These tales of how the twenty-five featured maker-artists interact with the people and place of Milton Keynes raise awareness of a sometimes hidden, but growing, citywide creative community. Milton Keynes' planners are keen for the city to be seen as 'creative and cultured' and to engage communities so that they 'flourish with artistic energy'. The maker-artists presented in this book and the artistic objects they showcase in the evocative photographs are an inspiration for the people of Milton Keynes and beyond.

# Fifty Years and More of Making Art in Milton Keynes

The ethos of Britain's Garden City movement, which formed the roots of the New Town programme, drew on the nineteenth-century Arts and Crafts Movement's ideals of high-quality design, skilled making and co-operation. The focus of this book on the hand-making of three-dimensional objects, many of which are functional as well as beautiful, makes the link from present-day making in this established city, back via Milton Keynes as a New Town, through Garden Cities, to the Arts and Crafts Movement. The Movement's ideals are in evidence in the meticulous making and sense of community described here by the maker-artists.

Since its founding, the planners of Milton Keynes have seen art as making an important social contribution to the lives of its people. This belief is reflected in the many examples of public art installed across the city. Back in the 1970s, artists in residence made iconic and enduring sculptures in collaboration with local school children. Liz Leyh's *The Tin Man* is now admired by a new generation of local children in the park at Beanhill, while her much-loved *Concrete Cows* are on display at the Milton Keynes Museum. Bill Billings'

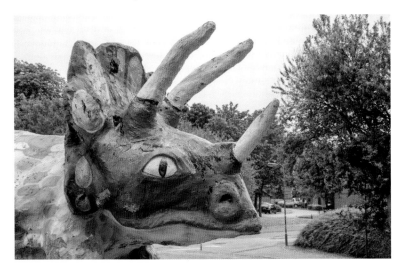

Triceratops *by Bill Billings, Peartree Bridge, installed in 1978.*

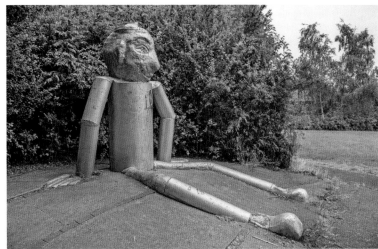

The Tin Man *by Liz Leyh, Lesley Bonner and Michael Grabowski, Beanhill, installed in 1978.*

*View from Arts Central, Norfolk House, Silbury Boulevard, Central Milton Keynes.*

*Dangerous Liaisons by Philip Jackson, Theatre District, installed in 1995.*

colourful *Triceratops*, another interactive public art project, was made in 1977 and still dominates open space in Peartree Bridge. Many more commissions have been made and installed over the subsequent fifty years. Since the Milton Keynes Development Corporation was dissolved in 1992 project-based funding for public art has been obtained from Arts Council England and the National Lottery, while other works of art are commissioned in partnership with developers. Recent examples include the eight installations on the Gyosei Art Trail alongside the Grand Union Canal, opened in 2016; while *Thoughts on a Bent Curve*, a huge sinuous polished Norwegian granite piece, made by sculptor Ekkehard Altenburger in 2015 sits outside one of the latest ultra-modern office buildings at No. 1 Delaware Drive.

The opening of Milton Keynes Gallery in 1999 ensures that national and international contributions to the creative life of the city are facilitated. Exhibitions of local artists' work have also been hosted there. The Silbury Group artists' collective, which was formed in 1991 and later moved to Westbury Arts Centre, held a group exhibition at MK Gallery in 2002 and renowned local artists, Boyd & Evans, exhibited there in 2005. More recently, the gallery's *MK Calling* exhibitions, held in 2013 and 2015, were designed to explore the breadth of creativity in or inspired by Milton Keynes. During 2017 the gallery's exhibition space will be expanded. Also contributing to the cultural life of the city, the Milton Keynes Living Archive captures local people's views and memories and shares them via a range of creative media.

Although artistic opportunities increased with the designation of Milton Keynes as a New Town, links to its more distant past can also be identified. Historic buildings, as well as modern spaces, are in use today as cultural hubs. The almshouses of the seventeenth-century Great Linford Manor House have been converted into arts workshops and the Old Woughton Rectory at Peartree Bridge, which was once a moated site, was until recently used by the community arts organisation InterAction.

Essence by Wendy Taylor, Saxon Court, installed in 1982.

Three Post Bench by Jeremy Turner, Gyosei Art Trail by Grand Union Canal, Bolbeck Park, installed in 2016.

The seventeenth-century Grade II-listed Westbury Arts Centre still hosts an active, independent artist-led charity, which has grown out of the earlier Silbury Group. In contrasting contemporary settings, the Arts Central group of artists have taken up temporary residence in a series of vacant modern office buildings including Station House, Norfolk House, and Clyde House in Oldbrook.

Providing evidence of creativity in even earlier times, a fourth-century Roman mosaic discovered at Bancroft Roman Villa in Milton Keynes is now on display in the main shopping centre. Within Broughton, one of the newest residential areas of Milton Keynes, the Victorian stained glass of the thirteenth-century St Lawrence's church sheds light on a series of impressive medieval wall paintings. The wall paintings have been used by one of the maker-artists as inspiration for an MK Arts for Health project that saw local people making mosaics, which now hang in the Milton Keynes Hospital.

These stories of the lives and work of the maker-artists of Milton Keynes highlight the inspiring mix of contemporary and historic artistic expression existing within the very modern setting of this city. This combination is providing Milton Keynes with a unique cultural heritage on which to draw as it thrives as an exciting, creative place.

# The Maker-Artists

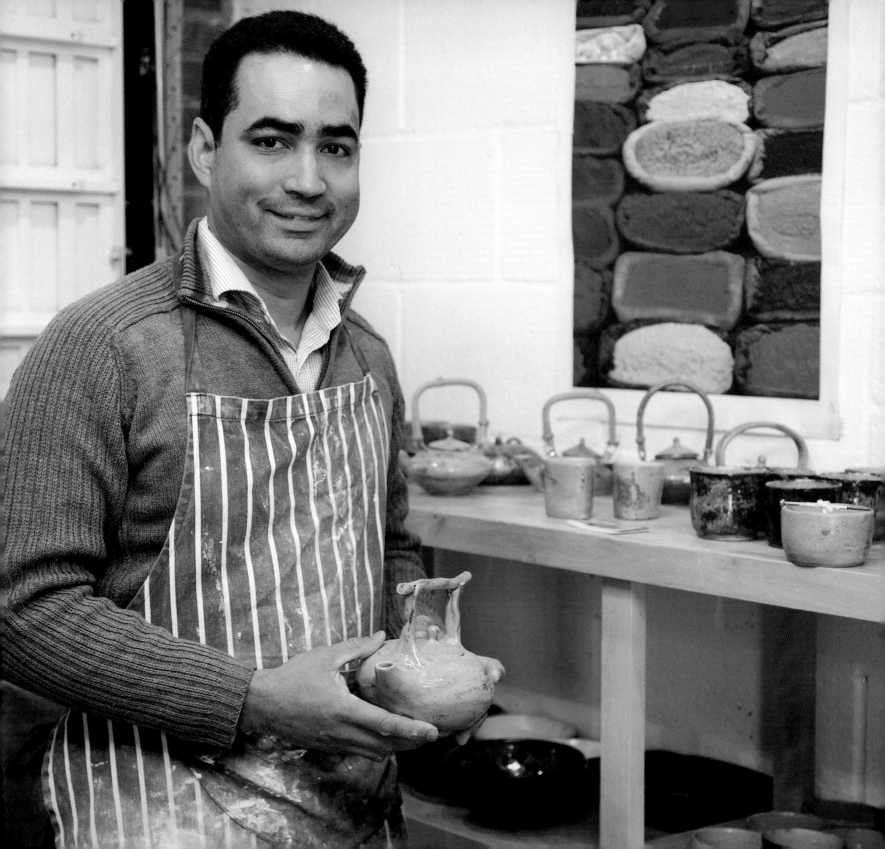

Teapots are what Juan loves to make the most in his converted garage studio. It is their combination of functionality and aesthetics, as well as their Japanese influences, which appeal to him. He enjoys experimenting with glazes too and may combine two or more commercial glazes to get the effect he wants. To continue to develop his own unique glazes is one of the many innovations he has in mind.

Juan's well-ordered studio is in the garage next to his semi-detached house, situated within a new estate in Woburn Sands. A large workbench dominates the central area while the shelves, which line the walls, are used to display finished items or to store semi-processed forms. A potter's wheel is at one end of the workbench, with a 30l kiln in one of the corners. He finds that a small kiln is 'very, very handy, because as a potter you have to try and test many things to get what you really want'. He goes on to explain about how different clays and a variety of glazes can be combined to give diverse effects. However, when he experiments, he has to be prepared for disappointment too:

It can be heartbreaking sometimes. You just spend a lot of time making an object and then when you put it in the kiln it can explode or the glazes can go wrong, and then you can't fix it; basically, you have to throw it away. You have to make another one.

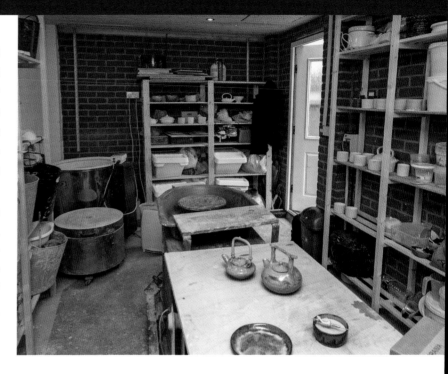

Much of the pottery, which Juan makes, is in shades of turquoise, mingled with rust brown accents. These colours and also the tactile quality of his work, are inspired by trekking trips to Venezuela's Gran Sabana National Park, which he took when he used to live near there. He has named his range of pottery after Roraima, the highest of the stunning chain of tabletop mountains in the region.

I love nature, I love rocks, the textures of rocks in different shades and the colours. So that was what I was trying to replicate in my pottery. So you see the colours I'm using are basically inspired by the colours I found in the mountains.

Born in London, Juan spent the formative years of his life in Venezuela, returning in his mid-twenties to learn English and ending up staying in England for the past twelve years or so. He has lived in Milton Keynes since 2006 and particularly likes its characterful areas such as Woburn Sands, Stony Stratford and Newport Pagnell. He recommends that 'if you look properly and you know where to go, there are a lot more things around Milton Keynes that people don't know about'. Although perhaps not as striking as Roraima, Juan also finds inspiration for his pottery from local nature. He likes to go mountain biking or walking in the nearby Aspley Woods, one of the reasons he chose to live where he does. In fact, several of his teapots feature wooden handles whittled from sticks picked up in this local woodland. And just down at the bottom of his road, in the centre of the newly built estate, a large natural pond forms a wildlife haven that he enjoys.

Although Juan now works full time in IT, he first became interested in ceramics when he was around 12 years old. He moved with his mother from the capital of Venezuela, Caracas, to the city of Merida in the Andes, where she opened a vegetarian restaurant. On walking around Merida, he realised that it was a haven for artists and makers, and he started watching them at work and as they sold the pieces they made at the local market. He was particularly inspired by the potters. 'I started asking

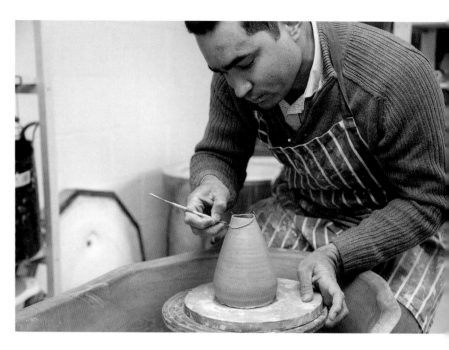

people how to make things, where to get the clay out, and I was getting the clay out of trenches and making stuff myself. And I just started experimenting, I loved touching the clay and I just fell in love with it.' His first pieces were little clay houses, which he sometimes makes even now.

University and work took over his life and he stopped making pottery for several years until fairly recently, when an artist friend suggested that he go back to it. Bells started ringing in his head and he thought, 'yes I can do it again, why not? What's stopping me?' He found a studio place at Inter-Action, a community arts organisation, then at the Old Rectory at Peartree Bridge in Milton Keynes, and enjoyed a year of mutual support with the other resident artists there. After the organisation had to vacate the Old Rectory site, Juan looked for other opportunities and decided that he would be able to set up a home studio in the garage of his new house. He has also built links with the potters at Westbury Arts Centre and has been to raku classes there.

'I just started experimenting,
I loved touching the clay and
I just fell in love with it.'

'I feel whole again when I'm making stuff on the wheel.'

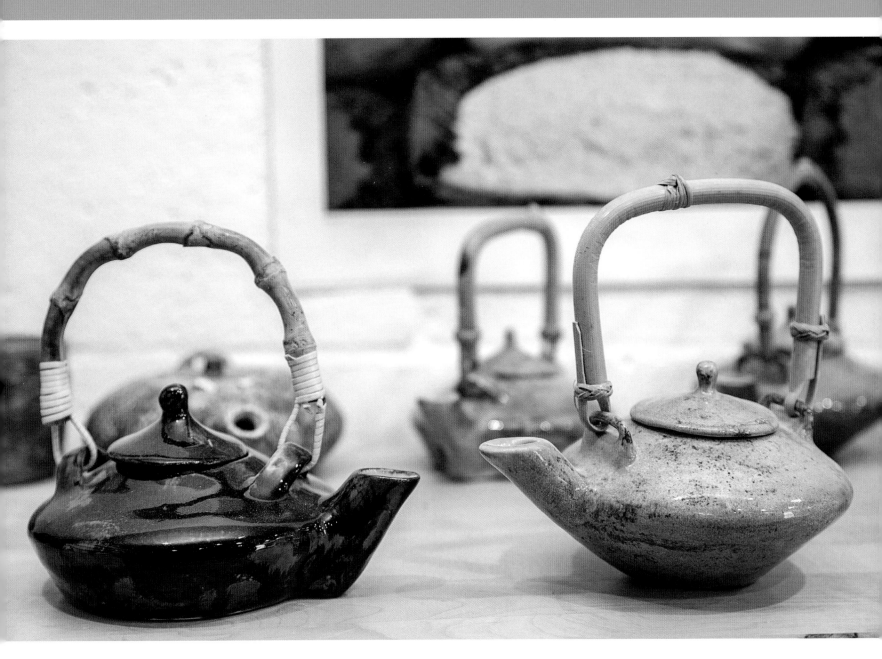

Making ceramics feels wonderful to Juan: 'The thing is, I feel whole again when I'm making stuff on the wheel. I feel, it's like you connect with yourself, put your soul into what you're making and you can get into like a meditation kind of state when you're doing it.' When you are in a relaxed and tranquil state of mind, he says, that's when you can make beautiful things. The only drawback is that pottery can take over your life he says, turning his girlfriend into a 'pottery widow' at times, as some processes need to be seen through from start to finish to avoid damaging the whole thing.

Lots of exciting challenges lay ahead as Juan rediscovers and further develops his passion for pottery. He already produces gorgeous little turquoise and rust-coloured cookware pots, which concentrate the heat to make amazing jacket potatoes. Next Juan is aiming to develop fireproof pots that can also sit on top of the stove. These need a special type of clay, which not many potters have developed the skills to use. He is also planning to make lamps by playing with stoneware and porcelain and light bulbs, probably going back to the tabletop mountain shapes for inspiration. His future plans certainly include a constant desire for the pieces he makes to be both usable and beautiful.

www.roraimaceramics.com

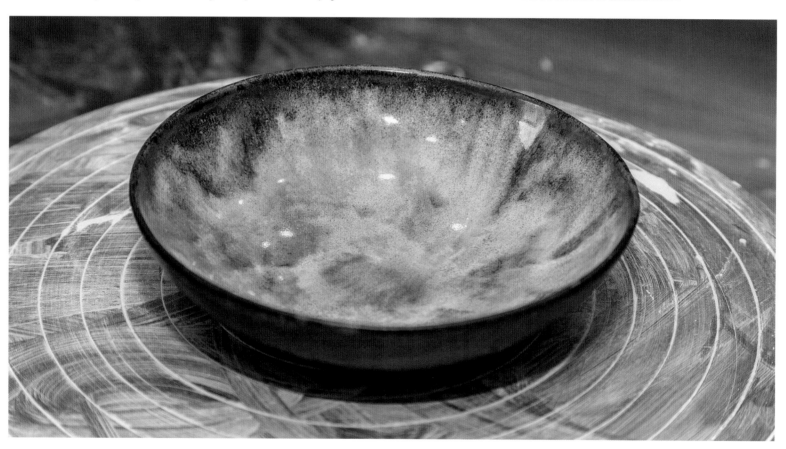

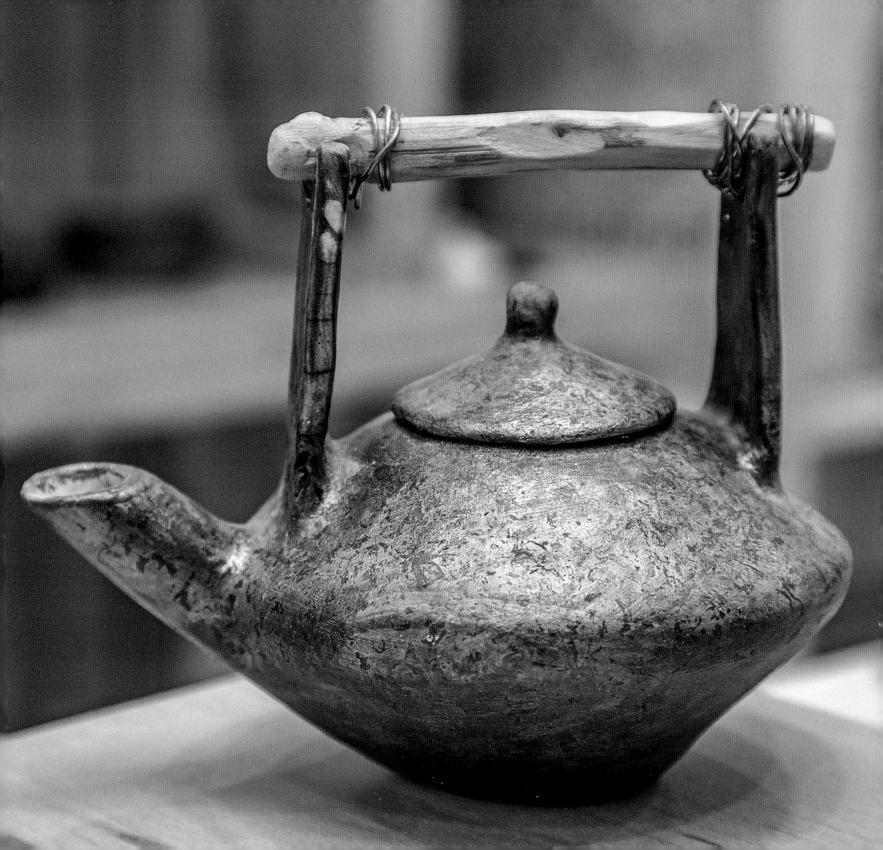

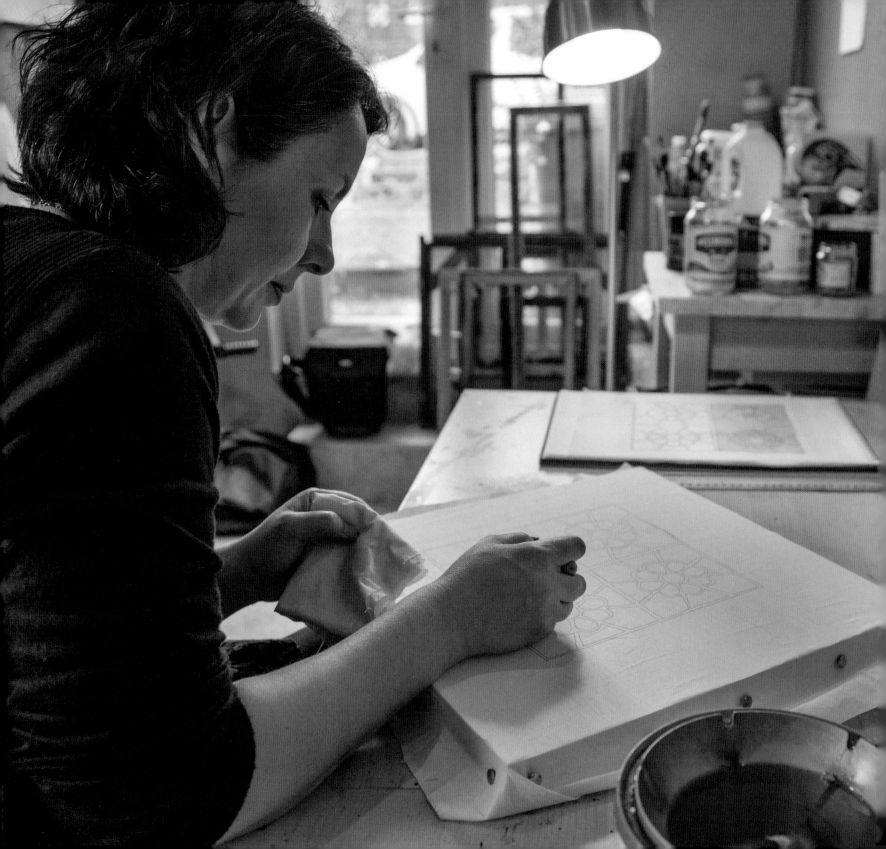

In the lovely little back room of her Victorian terraced house in Wolverton, one of the original founding towns of Milton Keynes, Jane has set up a welcoming studio space for her batik artwork. A clear light comes in through the windows, especially on sunny mornings and the woodburner keeps it cosy in the winter. The walls are hung with work in progress and a range of equipment stands ready on the wide desk and nearby shelves.

Jane explains that the particular technique that she uses is called faux batik: 'generally I don't do the dip-dying method. I might, occasionally for the last colour, but most of the time I will paint the colours on and build up the design that way.' The designs are complex and layered with the wax painted on, the coloured dyes applied, then sometimes some of the colour bleached out. Hand stitching provides the final level of intricate detail. Jane applies the soy wax with traditional tjanting tools. She did try beeswax once, but was put off that by the swarm of bees that were attracted into her kitchen by the aromatic pheromones given off as she heated it.

A bolt of ready-prepared Indonesian cotton provides Jane with the medium on which to work. It proves more robust for stitching than silk, for example, and she prefers fabric to paper. A selection of Procion dyes, which come in a lovely colour range and are easy to fix, and then washable, are lined up ready to mix. A big pan for boiling out the wax once the dye is dry and an old iron ready for ironing the cloth before the stitching stage, are the other main tools. Although batik textiles can be made into furnishings and

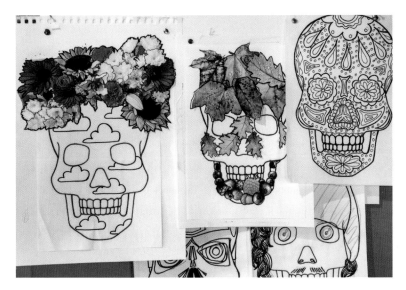

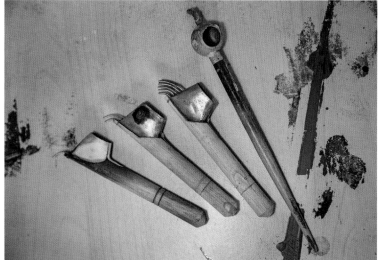

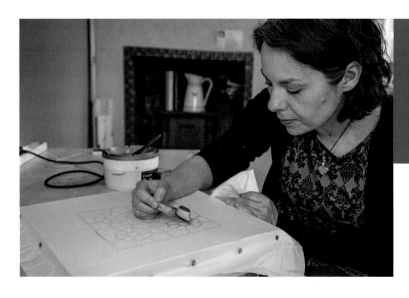

'I suppose in terms of themes I'm a bit of a ponderer on life, so a lot of my ideas come from big stuff, like why we're here and the human condition.'

clothing, Jane prefers to treat her creations as works of art to hang on the wall.

Jane's current series of batiks use a skull motif as a starting point. This collection is inspired by the popularity of the 'Day of the Dead' sugar skulls, a tradition from Mexico, and is associated with Catholicism. In Mexico, monks traditionally encourage local people to decorate skulls made from sugar on 31 October, as part of a holiday during which their deceased relatives are honoured. Rather than see the skulls as morbid, Jane likes to think of them as a projection of our own humanity: 'we're kind of stuck between that point of living and dying. Everything is living and dying all the time, seasons, animals, people, ideas, everything, it's always recreating and it's on a cycle all the time.' Finished pieces from the skull series are hung in Jane's living room, as well as in her studio. One has a blue-sky effect on the face, taking inspiration from Magritte, while another has a more autumnal feel with its shades of green. As in the Mexican tradition, Jane likes to use bright colours for the skulls: 'I love the vibrancy of it.' She calls another, with a springtime feel, the *Green Woman* and is pleased with the quirkiness of the skull with a fried egg on top.

A paisley design was inspired by the 'plague of tattoos' she notices these days, and she even made a *Terminator* version for her son, demonstrating the range of possibilities.

Each of the batik skulls takes a very long time to make, as they include lots of pattern, lots of colour and are finished with stitching and beading. Pricing her work for sale is tricky, especially if the number of hours spent on a piece is taken into account. 'If you've spent forty hours stitching and you're charging say £10 an hour, which is not a massive amount in the first place, that's £400.' However, Jane is not sure that people are willing to spend that much money on a textile piece, and wonders whether textile-based art has the same kudos as paintings.

Despite the practical and creative pressures of batik art, Jane does find it very therapeutic: 'It's what I call my bliss, once I'm doing it and I'm into it, I just love it.' Working in an adult education centre, Jane has offered batik courses but found that take-up was low. Even the nationwide Batik Guild has a dwindling membership, indicating that the technique is not particularly fashionable, although in general, 'textile courses are very popular at the moment'. What is needed is a BBC television series on batik to encourage people, she jokes.

Jane has lived in Wolverton for most of her life, moving there forty-two years ago at the age of 3, and attended Stantonbury School. She prefers the older parts of Milton Keynes, liking the closeness and diversity of the Wolverton community, where she can wave to people she knows. 'I feel quite grounded here.

'It does have a lot of history,' she says. She remembers growing up in the '70s and '80s in a little 'Wolverton bubble' and reminisces about cycling out to the north of Wolverton and coming across a new Redway they were building for cyclists and pedestrians as part of the development of Milton Keynes and thinking 'oh, this is the frontier'. She worries though, about whether the latest phases of the development of the city are remaining true to its original ideals.

Jane's work provides her with strong links to the city too. Her work is on display in the corridors of Wolverton's Old Bath House Community Centre, and she is collaborating with other textile artists to mount an exhibition for Bucks Open Studios at the Church of Christ the Cornerstone in the centre of Milton Keynes. Although having a home studio enables her to fit her batik in with working full-time, she does also envy the immediate artist community that is on offer at Arts Central. In the near future, she plans to attend other artists' batik workshops to get more ideas on how to develop and perfect her own skills, as well as aiming to teach others herself. 'I absolutely love doing it,' she says. 'It gives me real satisfaction.'

www.facebook.com/batikattik

'It's what I call my bliss, once I'm doing it and I'm into it, I just love it.'

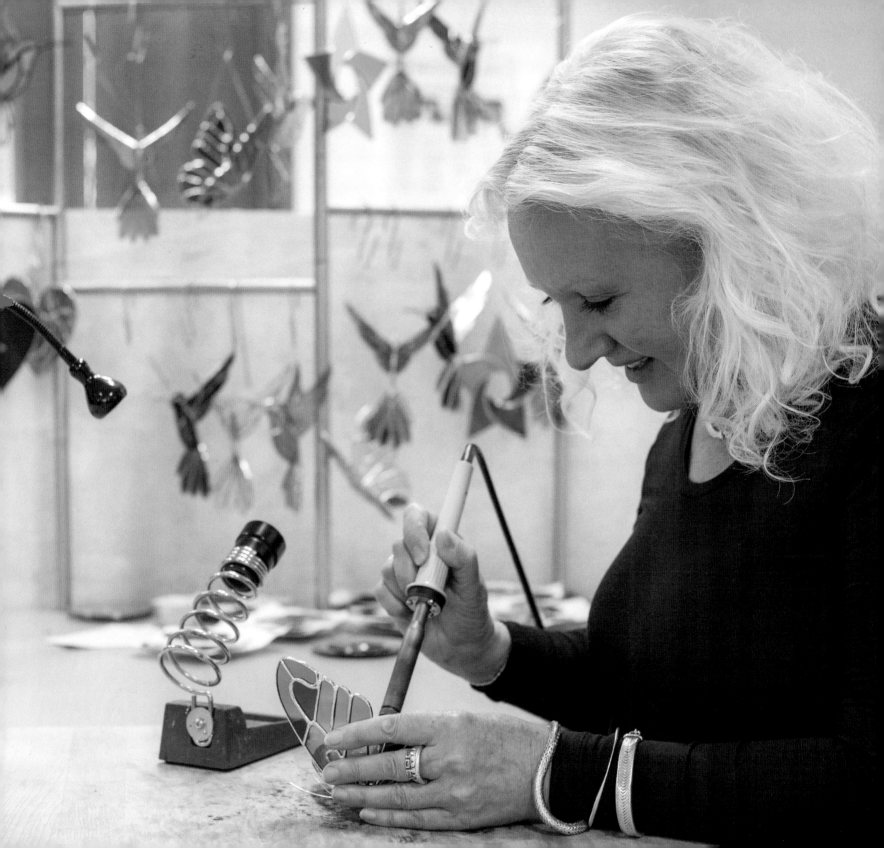

The gentle glow of Elaine's stained-glass butterflies and hummingbirds catch the light as they hover in space. Rainbow colours are enclosed by silver lines, created by fine soldering, which hold these delicate three-dimensional pieces in place. Using the Tiffany stained-glass technique Elaine creates a range of elegant designs that capture movement and have a sinuous grace in this beautiful medium.

A couple of 'window clings' bought at a craft fair in America travelled around the world with Elaine as her work took her from one country to another. She put them on her living room windows and wondered about how they were made. Now settled in Milton Keynes, she started experimenting to see if she could make one herself. Elaine first painted on acetate sheets and sold her work

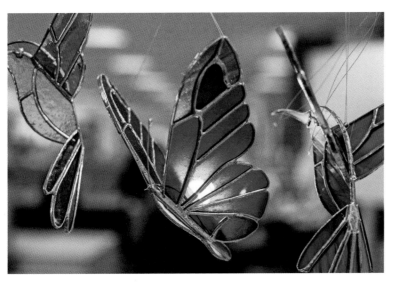

at craft fairs but soon wanted to create the translucent effect of painted colour on glass more directly. Three years ago she taught herself to make the three-dimensional stained-glass pieces that she is excited by today.

Learning from a book, YouTube and websites Elaine remembers, 'I made a lot of mistakes,' but she learnt from them. The Karal Studio website proved a vital source of inspiration and guidance: 'I just watched his videos over and over, and over and over and over again – until all of the mistakes that I was making, hopefully are now corrected and worked out'.

Unusually for a stained-glass maker Elaine began to work with three-dimensional forms from the start. 'I started with the hummingbirds; the butterflies came later.' She had seen something similar to the hummingbird in a garden in Manchester and tried to recreate it. 'The butterfly pattern is really a combination of about twelve different butterflies.'

The process of making is precise and requires a great deal of patience and accuracy. Elaine initially develops the patterns and chooses the different glass colours for the design. She uses a glass cutter to cut each piece of the pattern and admits that 'there can be quite a few mistakes, and sometimes a little bit of blood shed!' Glass cutting only lends itself to straight lines. Curves usually result in jagged edges, and most of Elaine's pieces are curved. The edges are then smoothed and curves refined on the grinding machine before Elaine wraps them in copper foil and fits them together. This step, a bit like completing a jigsaw puzzle, is 'the most important part'. She attaches the pieces

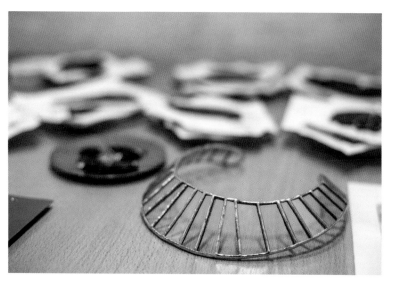
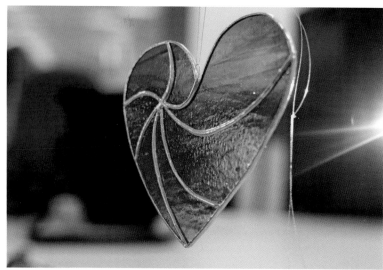

'You could be putting together a really lovely piece, but if the soldering is messy then it will just ruin the whole thing.'

together with angles so that they look fluid and initially she felt that she needed 'more than two hands to be able to do that!' She has now developed a technique to manage holding the pieces in three dimensions and the soldering iron at the same time. The assembled pieces are roughly held in place by tacking them together before applying the silver solder.

Elaine says that perfecting her soldering took a 'good couple of years' and even now she is modest about her skills 'I'm not sure if you can get perfect soldering, but almost perfect.' After soldering the piece can be quite sticky and 'dirty looking' and cleaning and buffing takes place before it can finally be strung.

New designs and bespoke work are tested out by making a prototype using cheap 'window' glass, as these trial versions often end up in the bin. The size and shape of the new design framework is vitally important. Today she is testing out the fit of a collar necklace for a commissioned piece with an empty frame before creating the final version, the colour range will be chosen by the client. Elaine's extensive collection of handmade glass comes in a variety of shades, patterns and prices. The reds, yellows and oranges are the most expensive as a working material as they have gold within them, necessary to create the colour.

Taking artwork seriously runs in Elaine's family. Her sister makes silver jewellery and her father spent his free time painting. Being involved in artwork was never seen as a 'waste of time' in the family and having a passion for art, in all its forms, is supported and understood. Moving into her Arts Central studio in central Milton Keynes has also provided Elaine with social support from a community of people who think in the same way. Moving from working at home with mess in the dining room and domestic distractions, Elaine says that being here has 'changed my life completely. Within three months I've made a huge number of friends and the atmosphere here is wonderful'. She suggests

that there is an untapped need for this type of provision in many communities to provide social contact for creative people working alone at home.

Running a business through various websites and stalls at craft fairs has its ups and downs. Returning home after a day in the rain with few sales can be disheartening, but when people are 'ecstatic about something that you've made, really, really positive', that brings immense pleasure.

Even so, Elaine is keen that her business does not become a production line and is currently thinking about simplifying her current offer – reducing the range of colours available in her hummingbird and butterfly designs. This will give her more time to move onto new designs and bigger things. She is currently thinking about making a stained-glass sailing boat with a three-dimensional hull and sails attached to it made from painted silk. The piece may be as much as 2½ft long – an enormous structural challenge in stained glass.

Elaine is not sure that she thinks of herself as an artist – perhaps more of a technician at this stage in her making. 'When I'm at that point when I'm really creating things that are totally unusual and have come entirely from within, I think that perhaps then I can call myself an artist.'

These three-dimensional stained-glass creations are getting larger and more creative as Elaine develops her confidence. It will be fascinating to see what she can do with the many ideas that she has for the future.

'I like the intricacy of using very small pieces of glass.'

www.elainemarsharts.com

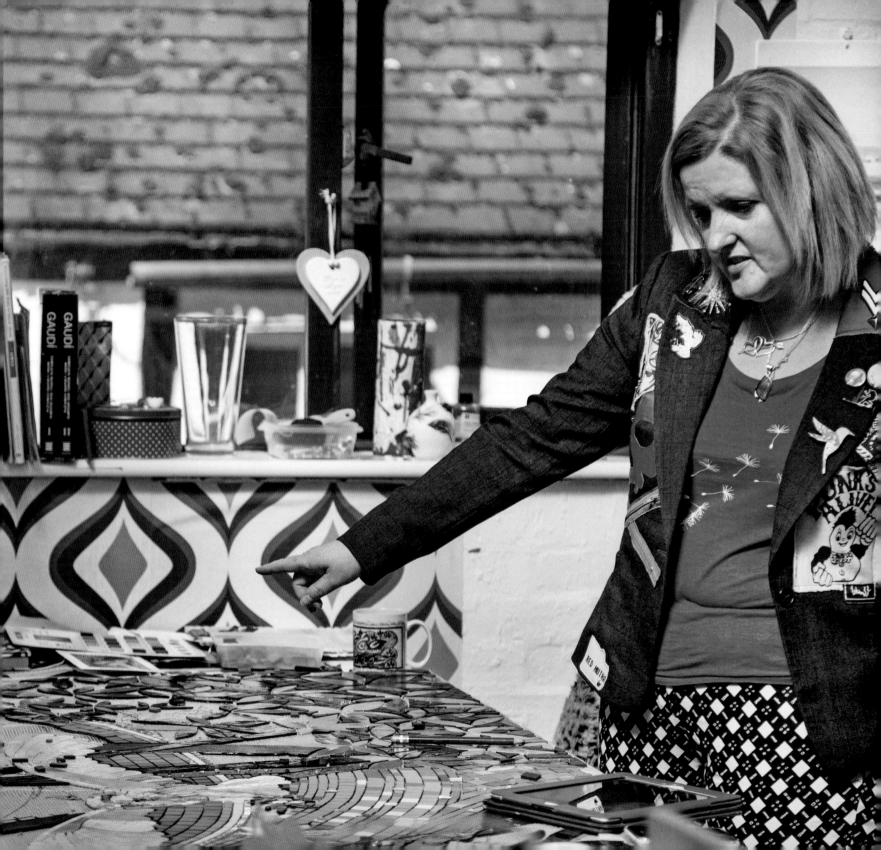

I nfluences from across the world and from the historical past are brought together in Melanie's mosaic art. The ideas and interests of the people of Milton Keynes also play a part in the shaping of many of her designs. As well as responding to these wide and varied influences, Melanie's work has an uplifting impact on local life.

One of her many commissions was installed on the Gyosei Art Trail in 2016 along the Grand Union Canal in the Great Linford area of Milton Keynes. Like much of her work, this piece emphasises collaboration. Six artists, each working in a different material, were commissioned to make art for the new trail, which commemorates the legacy of the Japanese Gyosei International School. The Trail encourages visitors to walk along the canal, learning about local history as they engage with the beautiful artworks.

Local people also contributed to the design of the Gyosei mosaic by attending an Open Day in Great Linford, where they were able to help choose the themes for the artworks. Melanie chatted to people at the Open Day and found that they 'liked the idea of doing wildlife, especially endangered species, so I have actually used a barn owl in the mosaic to draw attention to the fact that they are endangered'. The barn owl, set in autumnal light, which bursts in at the top left of the piece and fades out towards the bottom right, looks stunningly luminous. The intense colours, characteristic of contemporary mosaic art, are based on

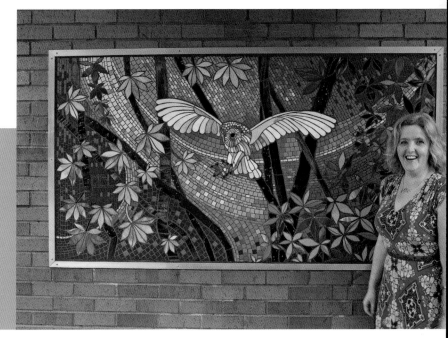

'There's something about mosaic, to do with cutting small broken pieces and making a whole, I find that very, very, therapeutic and rewarding when it's all finished and grouted and it all comes together.'

photographs Melanie took of the vibrant yellows and oranges of Great Linford woods during the previous autumn. The mosaic materials are stained glass and porcelain and the completed piece has now been framed in aluminium, cemented and bolted onto a wall at the end of one of the canal's bridges.

Located in the historic town of Stony Stratford, one of Milton Keynes' original anchor towns, Melanie's studio is large and glass-roofed. The light streams in, which is great for her intricate artwork, although very warm when the sun shines. Through an archway at one end of the studio is a kitchen and sorting area for her Age UK neighbours, a place where she can chat to the friendly volunteers, and be inspired by the 'lovely treasures' they get in as donations. The Gyosei piece, nearing completion,

sparkles on her large workbench. Melanie finds her studio space a great place to work: 'It's important to me to be in an environment where I feel relaxed.'

She uses a variety of tools, including double-wheeled Leponitt cutters and oiled glass cutters to cut the porcelain and stained glass. In contrast to these modern tools, a traditional hammer and hardie set, used for cutting stone, stands nearby on a small tree trunk. Melanie is enjoying mastering the old Italian techniques associated with these tools. She has been making mosaic art since 2009: 'I love the range of materials and the fact they're so versatile and have such long life and you can put them on walls and flooring and they'll literally last for hundreds of years, which I find brilliant.'

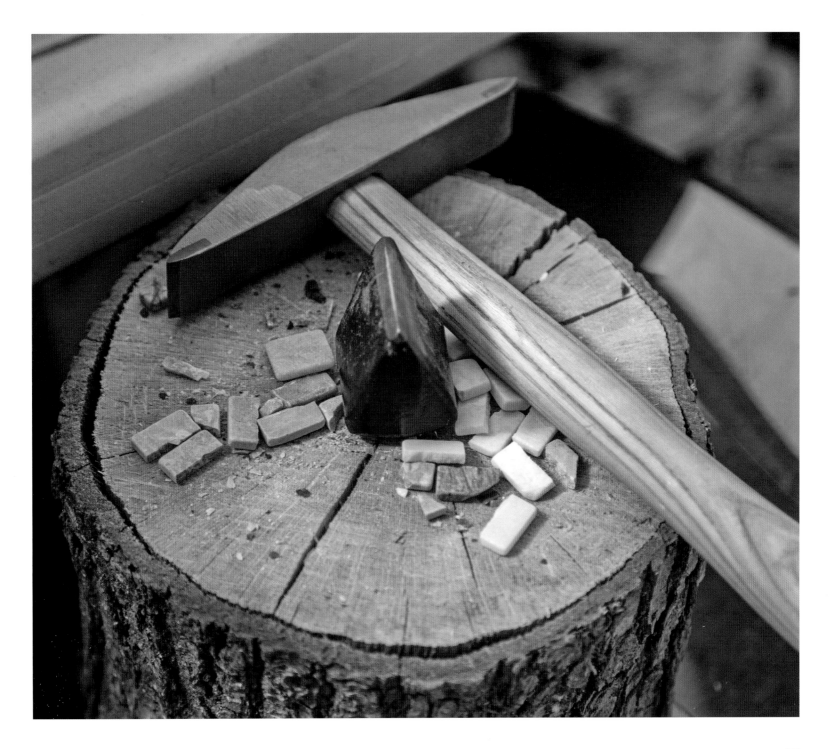

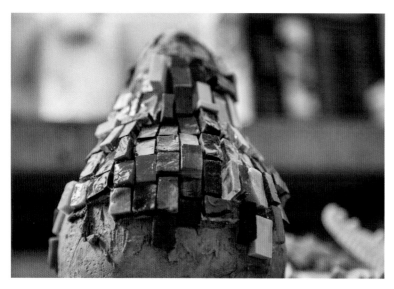

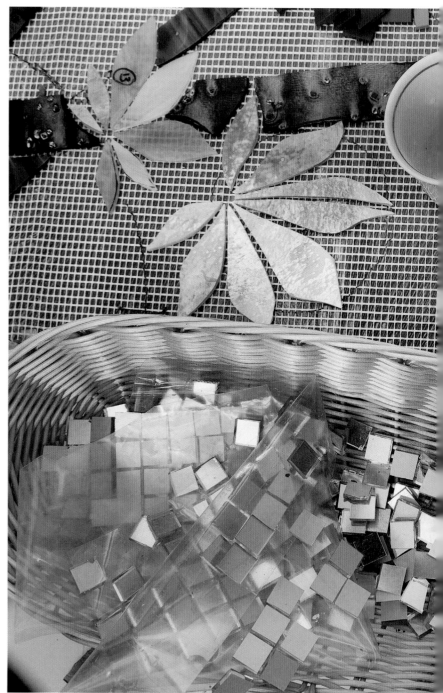

She has always had a gift for art, getting a placement to do a BTEC in Art and Design for two years when she was 16. She has stuck with an artistic career, which has taken in fine art, murals, ceramics and wallpaper design, despite the financial challenges. She finds mosaic particularly enriching: 'there's something about mosaic, to do with cutting small broken pieces and making a whole, I find that very, very therapeutic and rewarding when it's all finished and grouted and it all comes together.'

Although she lives on one of the newer estates of Milton Keynes, Melanie loves working in Stony Stratford 'because it's so historic here and you can feel the history here and that's really important to me as an artist'. Although the nooks and crannies of old buildings appeal, she is also interested in the newer aspects of Milton Keynes: 'It has a lot of little gems here already, and I think it will be really interesting in my lifetime to see it develop, to see what's going to happen here.' She has been involved in many projects in the area, including a project for MK Arts for Health in which she encouraged local people to make mosaic art by taking inspiration from the murals in

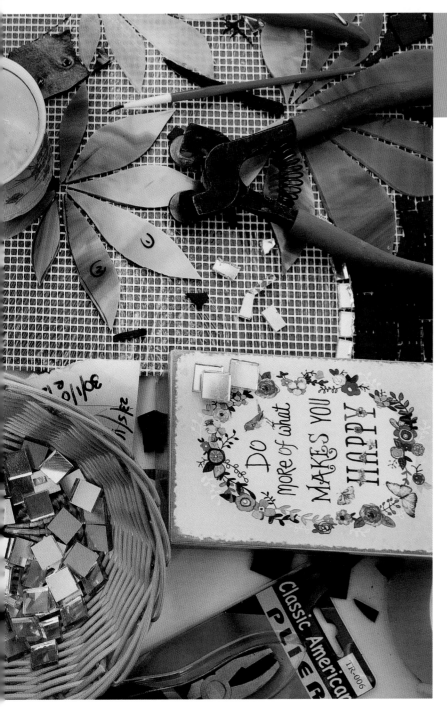

'It resonates with people, it uplifts people and that's what I really like. It makes them feel good and lifts their spirits.'

the ancient church of St Lawrence's in Broughton. The mosaics made by the students now hang on the wall of Ward 22 in Milton Keynes Hospital and making them was of great benefit to the participants too, as Melanie explained: 'It resonates with people, it uplifts people and that's what I really like. It makes them feel good and lifts their spirits.'

Her mosaic art has taken Melanie beyond Milton Keynes. She worked collaboratively with eighty other artists from around the world on a large-scale project in Chile, producing a gorgeous mosaic based on the flora and fauna of Chile. She has noticed the difference between the fairly low level of activity and interest in mosaic in the UK, and the high level of interest in the art form in the rest of the world. During the Chilean project, hundreds of people turned up to watch the artists in action every day. They were filmed, a book was made and they had a massive following on social media. Interest is also high in Belgium, Italy, Spain (in particular Gaudi's work in Barcelona) and Morocco. She finds it amazing that 'in every country they've got completely different styles in the decoration they use, the imagery they use, it's just all so unique'.

She is impressed by the extent to which mosaic art is exhibited in overseas galleries and that finance is available there for large-scale projects. She would love to do a big mosaic project in Milton Keynes and 'really get the public looking at what we're doing, get lots of artists involved, it'd be amazing'.

www.melaniewattsmosaics.co.uk

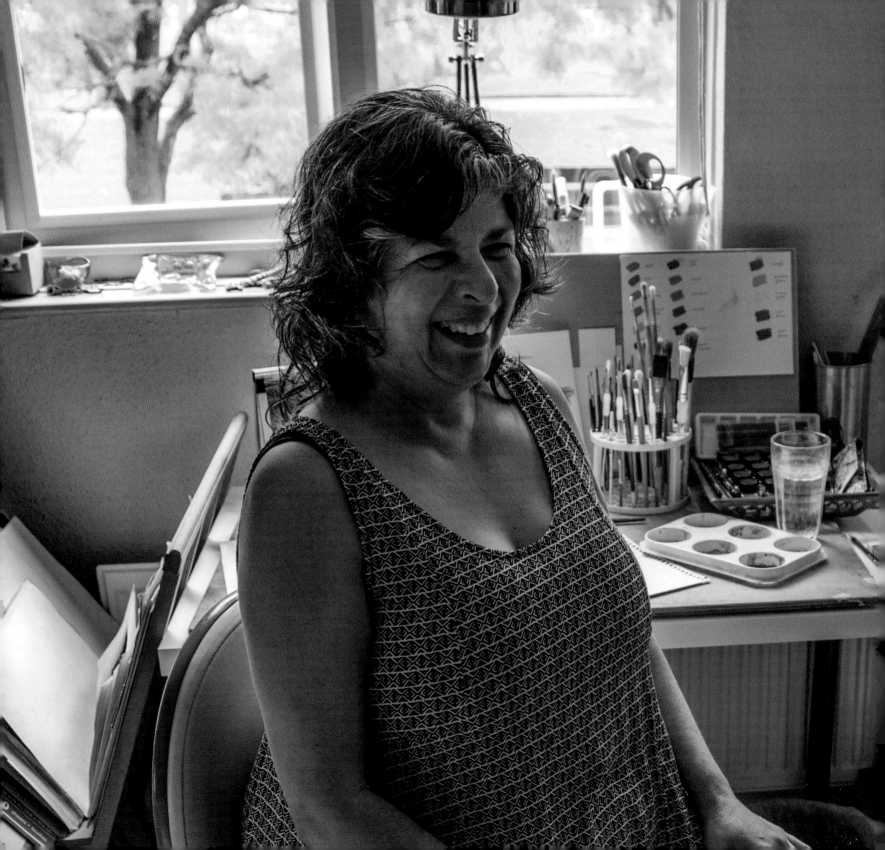

# Soraya Billimoria

## MULTIMEDIA ARTIST

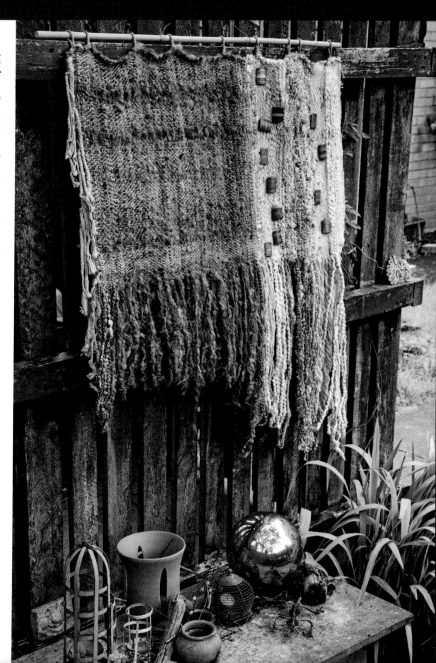

Over the past few years, Soraya has been rediscovering her artistic skills. With her son grown up and off at university, she has had the space and time to experiment. Back in the early 1980s she did an Art and Design Foundation course, following on from an A Level in Art. Then, other demands in life meant that she laid down her brushes in 1985 and didn't pick them up again until twenty-five years later in 2010.

Examples of her recent work are everywhere in her house – beautiful pots, tactile weaving, exquisitely coloured brush and ink drawings. Some, such as the gorgeous uplifting piece of weaving in shades of blue, glinting with textured ceramic fish, mix media. Soraya explained the creative process behind this particular piece: 'I like to weave in a quite abstract fashion. So I try and find yarns that will do what I want them to do, so depict wave, foam and water, and particularly for this one, I wanted to make some little fish.' Making the fish proved tricky and exciting. After Soraya had handmade the fish in clay and applied a glaze, they were fired outside in a fire pit using the raku technique. Taking them out of the kiln was a bit of a challenge though.

Basically what happened was they had to be put into a sort of handmade clay basket to be fired. As we were taking them out, the basket collapsed. So all my little fish ended up in the grass and it was a mad scramble. And bearing in mind that this is thousands of degrees hot, so you can't pick them up with your hands, we had these great big heat-proof gloves that we tried to pick these little fish up with.

'I like to weave in a quite abstract fashion.'

Luckily the fish were rescued and look very happy nestled amongst the woven azure-hued fibres.

Perhaps it is her Pisces star sign, but Soraya is very drawn to using fish as a motif in her art. The stunning depth of colour in many fish is really the main inspiration though. For an upcoming exhibition, she has just completed a series of beautiful brush and ink paintings of fish, which develop their shapes and colours into a semi-abstract form. For these she has used water-based

'There's just such a brilliance, the light is just different, there's a deeper saturation, and colours just stand out. And I just wanted to carry that back into my art work once I got to Britain.'

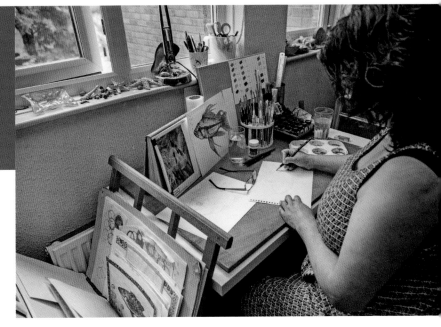

Windsor and Newton inks, which she loves for their jewel-like colours and the textures they can give. An array of fastidiously clean brushes, with the finest ones readily to hand, are in a rack on her desk.

Soraya is gradually converting her student son's bedroom into a studio where she can have space for making art. His posters are still up on the wall, although Soraya is wondering when she might be able to take those down and put up her own work. Luckily her son is very supportive and is actually pursuing a creative path himself in industrial design.

As one of the earliest residents of the new town of Milton Keynes, moving in to one of the houses in Coffee Hall as an 11-year-old, forty years ago, Soraya has seen the town grow and change. Although she finds the box-like houses on the estates rather boring, there are many things she finds visually pleasing about the town. 'I like all the reflections in the centre and I love the fact that there's so much green space around Milton Keynes and that the Parks Trust look after that for us.' She finds the Tree Cathedral at Newlands particularly inspirational. Soraya actually helped to shape the town as it was growing and developing. Soon after she moved in she was able to contribute to the town's artistic environment, including being involved in making the iconic concrete cows sculptures: 'I helped to build one of the baby cows.' The concrete cows are now back grazing in the grounds of the Milton Keynes Museum after a few years' display in the shopping centre. In the late '70s, she also helped to paint a mural on the underpass between Coffee Hall and Beanhill, using the theme of *The Wizard of Oz*. A metal and concrete sculpture of *The Tin Man* was sited in Beanhill as part of the project and can still be seen there.

Before arriving in Milton Keynes, Soraya spent the early years of her life in Kenya. She sees her roots as being primarily African, although her great-great-grandfather had moved to Kenya from India, so she does also have Asian heritage. Her last visit to Kenya, in 2009, is still influencing her art. Her ceramics have an African feel in their colours and textures. What really had an impact though was the sunlight she noticed when she was there:

I remember waking up the day after we'd landed and thinking, wow, there's just such a brilliance, the light is just different. You really notice it, just the clarity, it seems there's a deeper saturation, and colours just stand out. And I just wanted to carry that back into my artwork once I got to Britain.

The medium of inks captures that depth of colour she says. Also linked to the role of sunlight, she is starting to experiment with cyanotype printing, which uses the sun as an activator onto sun-sensitive paper. Cyanotype printing also enables Soraya to draw on the photographs she takes of natural forms while out walking. It's a very interesting process she explained: 'I've done this print and created it as an invert image, so it's a negative image, so all the areas that are white will turn blue and all the darkened areas will remain white.' Also emphasising depth of colour, Soraya is starting to use Brusho (an incredibly intense pigment powder) in her work too.

Despite not practising art for several years after art college, Soraya has close links with the Milton Keynes arts world. She worked in the Milton Keynes Exhibition Gallery until it was replaced by the MK Gallery in 1999 and was involved with Arts Central for a while. For Bucks Open Studios 2016, she is exhibiting in nearby Pottersbury with local artists, including another Milton Keynes artist. She is looking forward to stretching herself, trying out different mediums and different techniques. And one day soon, will perhaps fully convert her son's bedroom into her own studio.

www.facebook.com/SorayaBCreations

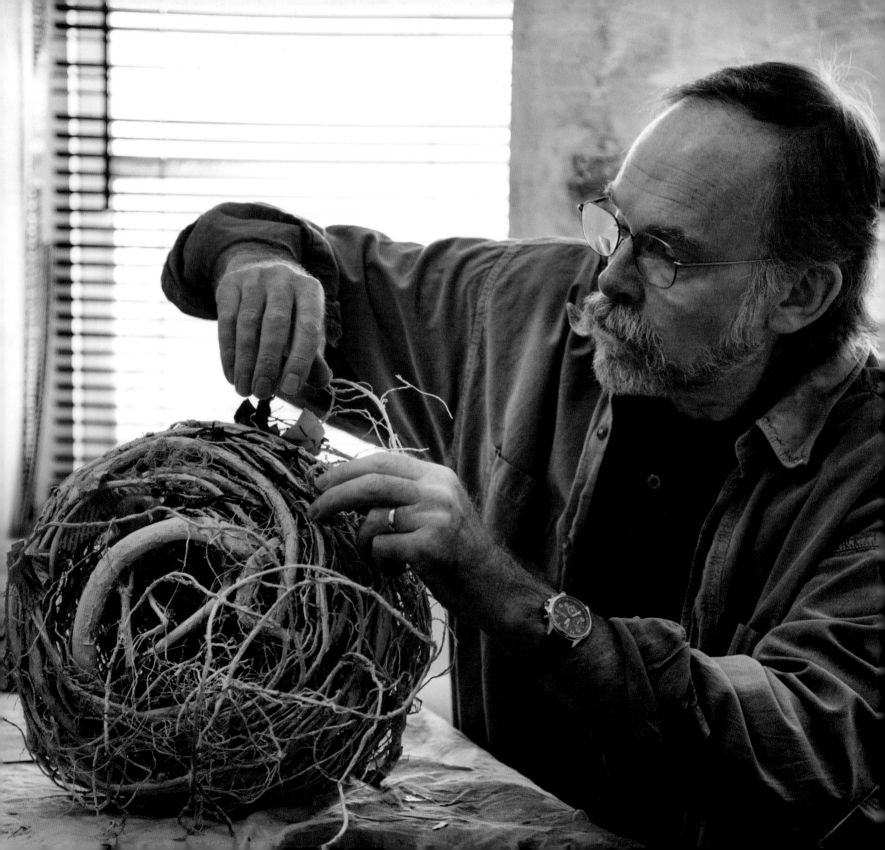

# David Whittington-Jones

## ASSEMBLAGE

**A**photographer by nature and training, David manipulates and extends that medium to explore and create three-dimensional work, which engages the eye and challenges the viewer to consider new perspectives. These 'assemblages' confront and challenge common ideas about past events and human relationships with the world. Natural and man-made objects work in parallel to focus the viewer's attention and demand an appreciation of the detail in these delicately coloured pieces.

After twenty-five years as a lecturer in photography David moved into a small darkroom under the stairs at Westbury Arts Centre to develop his accumulated photographic negatives. He soon realised that what he really wanted to concentrate on was 'something else', to develop and engage with themes and cultural issues that he had thought about for many years. The themes are big: the impact of the First World War, the value of culture and history. He has concerns about whether there was a 'sense of loss of moral compass' and brings our attention to that in his work, yet at the same time describes a 'disarmingly damaged sky' and the joy of being able to 'rest the eye on an object in the composition and say "This is pleasing, I know where this has been, and actually, there's the mark of time"'.

This change of direction has resulted in work, which David describes as assemblages. Old pieces of wood, a speckled rock resembling a wild bird's egg, a very rusty key from a church, a broken watch, old nails and other found objects arranged on a base of wood which has been 'surface treated', worked into

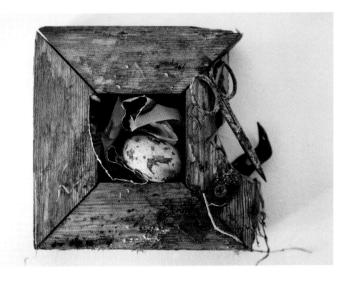

and layered with paints, photographs and old newspapers. The pieces are carefully placed and rearranged. David describes the piece he is currently working on where the pieces are 'in parallel, they never actually touch'. Natural objects are alternated with man-made objects, generating a pleasing contrast and a desire to take a closer look.

David develops and extends his skills as a photographer through two lines of work: photographs that 'take the three-dimensional qualities and reduce them to two' and the three-dimensional work, which uses photographs and other papers as components of the assemblage of objects. These are carefully crafted. He has created labels, newspapers and images to fill a small wooden box and used a restructured map to frame an old photographer's negative case in

'You can use a medium to explore the world, to examine its foibles and its troubles and also to celebrate the joyous and wonderful.'

pieces from his Milton Keynes series. His show *Requiem – Memory as Process* (2015) challenges ideas about history and memorabilia, presenting iconic objects in new configurations. In a photographic triptych the face of an attractive young woman in a veil from the 1920s draws the eye. Taking a closer look reveals that the gauze is made of metal and corroded, both attractive and repulsive at the same time, evoking the tensions of women remaining at home yet constantly aware of the horrors of war. In the photographs of these 3D assemblages David focuses our attention on one single object by using a shallow depth of field, drawing attention to the artefact in sharp focus. In the assemblages themselves he hopes that people will 'just enjoy the sheer physicality of the object', which is taken out of context and associated with another.

Being inspired by themes concerned with substantial human issues presents challenges. Much has been done before and clichés and common associations need to be avoided. In the *Requiem* work David has consciously omitted the poppy as a signifier, leaving that association with the Great War to others. He feels both disappointment and pleasure in the digital world, which has made capturing and manipulating images deceptively easier, yet just as easily they are swept away and rendered 'invisible' in time. David's move to assemblages, a tactile medium, resonates with his idea that objects can nurture a sense of well-being, 'a sense of comfort from the fact that there was a past in which things were solid, were real, and that those things can be had, or hung onto' in the present day.

Now in an artist's studio at Westbury Arts Centre, David is pleased to work in Milton Keynes with local archaeological findings suggesting that the area has been occupied for millennia. The house itself is 'full of atmosphere that you can't escape and that's wonderful'. Local connections and family are supportive of his work and he is hopeful that the planned expansion of Milton Keynes will be friendly to local artists, offering more opportunities for them to show their work.

Admiring a wide range of artists' work, David is inspired by a 'general spirit of production, of making things' that he recognises in the work of others, whatever the artists' practice. Pressed to name one 'heavyweight', he recalls seeing Anselm Kiefer resolving an unfinished work with a machete and being impressed with the scope of thinking and scale of production.

Although he has been tempted to return to formal teaching, after twenty-five years he explains that now is the time to concentrate on his own artistic work: 'trying to engage people, trying to get them

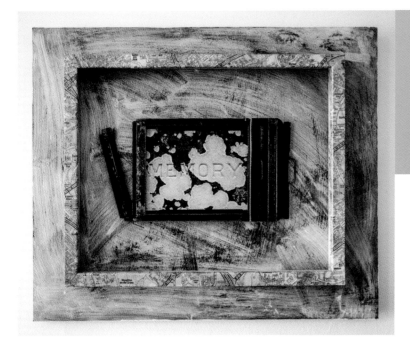

'To celebrate the 100th anniversary of the Rangefinder camera I built this piece out of wood and bits of scrap. It resembles most of the types that were ever built, but by the same token it's actually none of them.'

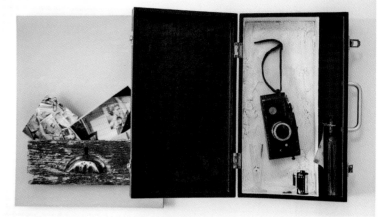

thinking about things which I believe are of value.' And, of course, he also has to try and resolve some of the problems that arise from developing a new way of working with assemblages.

David is currently working on his next exhibition, which considers how ways of representing our culture are changing. Working on how to make that invisible change visible through exploring the secular relationship we now have with religious pieces of art and the ways that we engage with natural and man-made objects.

He adds that he would like to make the photographic element of the work larger within the constructions and the assemblages themselves are growing in size. Still a dedicated photographer, David finds that the assemblages are now informing new approaches to image making.

www.blackswanphotography.uk

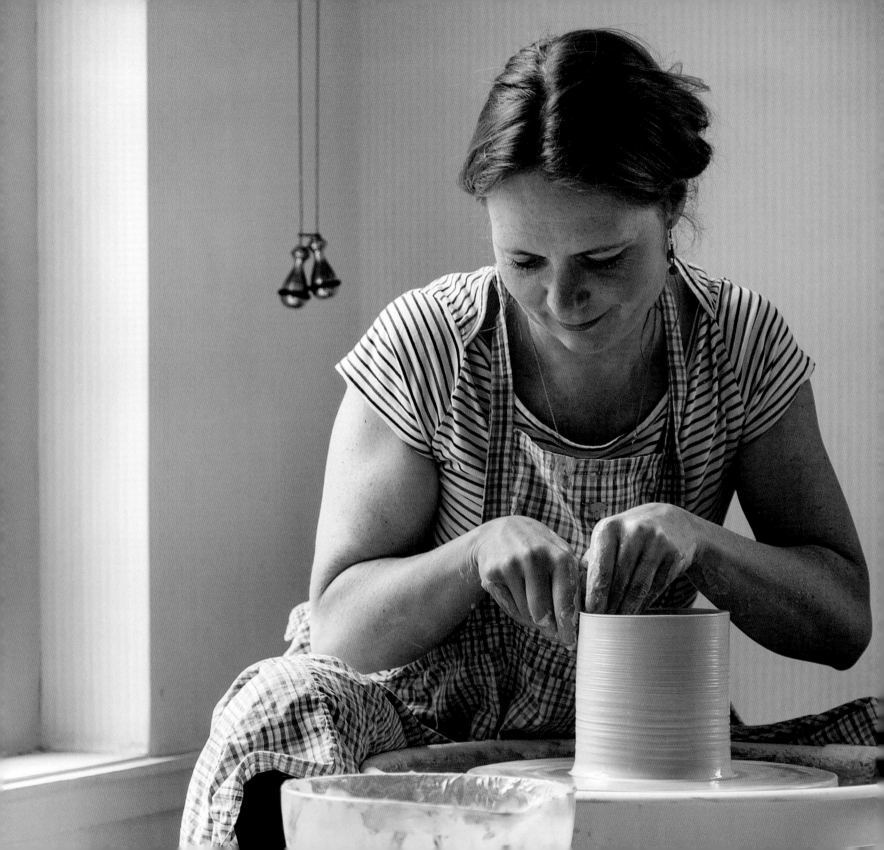

Strong Danish influences can be seen in the clean, fresh look and simple organic forms of Rosa's pottery. This is not really surprising, as she is originally from Denmark and studied for five years at Denmark's top design school in Copenhagen. After several years working in fashion design in London, she now lives in a gorgeous 100-year-old Grade II-listed house in Great Brickhill, a village on the edge of Milton Keynes. Leaving behind womenswear and childrenswear design, Rosa now focuses on designing and making ceramic tableware and passing on her skills in ceramics to others.

When she lived in a small house in London there was no space for a potter's wheel or a kiln. Now, with masses of space available, she has set up a firing and storage room down in the basement and a throwing space in a corner of one of the downstairs rooms. Rosa chose 'The Whisper' as her potters' wheel mainly because it is one of the quietest wheels you can get. Even while the wheel is going, she can still carry on a conversation, listen to the radio, or keep an ear out for what the children are up to. The wheel sits in a corner of the spacious high-ceilinged room with enormous windows through which chickens can be seen roaming around the lawns. Rosa says that the chickens often keep her company, peeking through the window at her while she is throwing pots. At the far end of the room mid-century modern Danish furniture, inherited from her family, adds to the creative feel, while textured rugs spread on the warm parquet floor provide play space for the children.

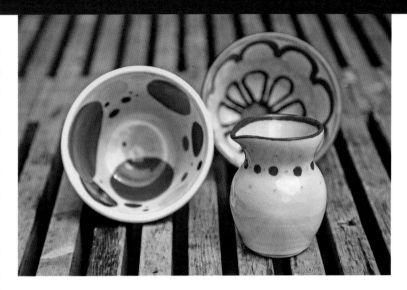

'If you want to throw a really, really fine, thin pot or a really big pot, you have to be there now, you can't think about what you're going to have for dinner, because if you wobble your hands, that's it.'

Rosa mainly makes tableware such as bowls, cups and jars. 'I quite like using things that I make instead of just having them to look at,' she explains. Practicality is also important to her: 'If you use them every day, you learn what's functional and not functional, which shapes work when you've got them on the table.' She mainly uses white stoneware clay, but has recently started to experiment with black and lavafleck clay. Sometimes she uses agate technique to enhance the design, which is where she combines the two types of clay. Looking at one of these examples, the lavafleck has been successfully confined to just the inside of the pot: 'so it has this organic feel but looks quite clean at the same time.'

To other pots she has added hand-painted motifs. One of her hand-painted designs draws on the influence of her grandmother, who was a porcelain painter and passed on her collection of books of designs to her granddaughter. She has tended to use bright colours, such as yellows and dark blues and greens. These glazes are really for porcelain, she explains, so they produce a strong effect. Recently she has started using more transparent glazes, liking the watercolour feel and the effect of being able to see the glaze.

The importance of fully engaging with the throwing process is part of Rosa's creative philosophy:

What I love with pottery is that you can't think of anything else when you're doing it. If you want to throw a really, really fine, thin pot or a really big pot, you have to be there now, you can't think about what you're going to have for dinner, because if you wobble your hands, that's it. You have to start all over again. So I really like that you have to concentrate. I think in the modern life we live in now, we are always doing ten thousand things at the same time. We never just sit. But when I do this I just sit, you can't do anything else. You can't talk on the phone at the same time, you just have to do it.

Having lived in Milton Keynes for almost a year, Rosa is starting to get involved in community life. She has been along to Women's Institute (WI) meetings and has several regular local students who enjoy coming to her house to eat cake and try out ceramics techniques. She is looking forward to the opening of Great Brickhill's newly revamped local pub and the landlady likes Rosa's suggestion that she hangs art by the WI members on the walls.

Rosa has also enjoyed a cup of tea and a chat about glazes and raku firing with the artists and makers based at Westbury Arts Centre in Shenley Church End. Experience of the local natural environment translates into Rosa's work too. She runs regularly in the nearby woods, enthusing about the organic feel and how the shapes inspire her: 'It's so beautiful with the bluebells growing wild everywhere and everything is so green and wonderful.' Taking this a step further, she encouraged one of the students in a recent pottery workshop to press leaves directly into the clay, which Rosa thinks was a great idea of hers.

Next, Rosa plans to start making her own glazes to make her pots even more distinctive. The potential for experimentation appeals: 'because you don't want to have a glaze that somebody knows that this is Pottercraft Number 45, you want to have your own glaze.' She would also like to try out raku firing in the garden – there is plenty of room for it after all.

www.facebook.com/rosaspotterystudio

'I think people want to sort of go back to the roots and enjoy life. And sitting with a nice cup of tea with a nice lovely handmade mug does taste better.'

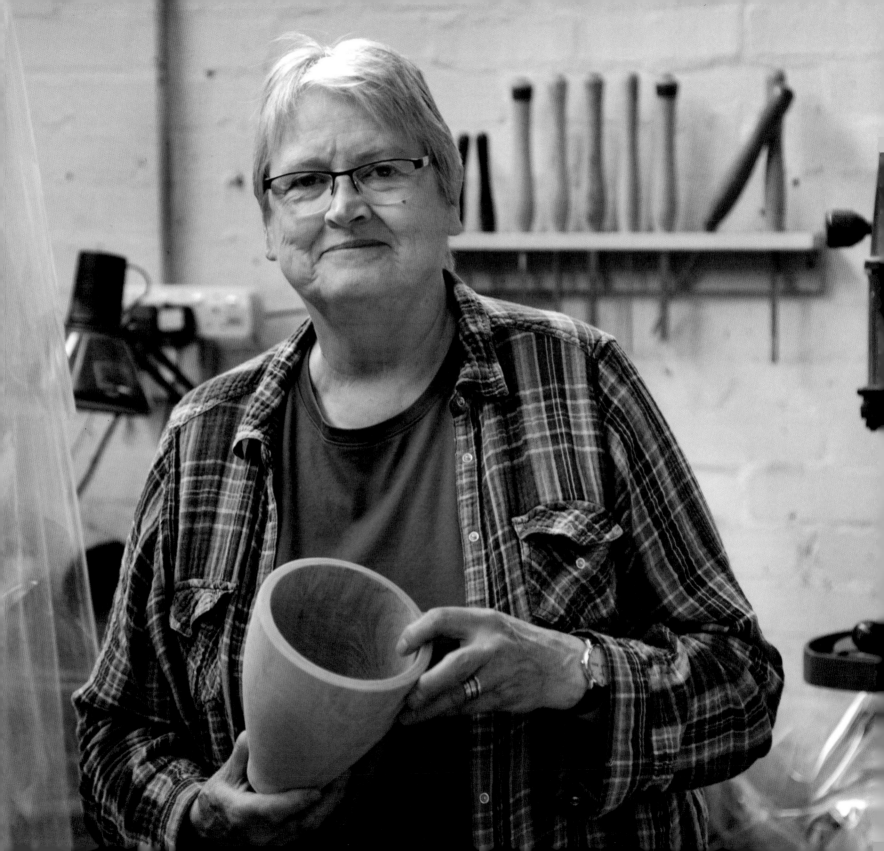

# Rosemary Wright

## WOODTURNER

Rosemary makes beautiful and useful things in wood in her atmospheric space at the gloriously gritty studios, tucked away behind Londis in Galley Hill. Although the building is shabby, rather than shabby chic, the sense of having had a chequered history adds to its charm. Amongst the imposing metal machinery, Rosemary's gorgeous wooden art forms gleam with burnished depth.

Light streams in through the high windows, giving glimpses of graffiti-strewn brick walls and a metal barriered overpass. The studio space is big and comfortably messy. Rosemary points out her two lathes and the table saw, which also acts as a workbench. She has a planer too, which is currently hidden below the workbench. A chainsaw is used out the back for cutting up big chunky tree trunks. Once the wood is reduced to a more manageable size, Rosemary explains the next step: 'I've got a thing called an arbortech, it's basically an angle grinder with a sort of chisel-type disc on it that you can shape and knock the lumps off the corners.'

A demonstration of how one of the lathes functions involves Rosemary donning an enormous, post-apocalyptic, gas mask-style helmet complete with a built-in respirator, so that she can avoid breathing in the wood shavings dust. The wood is mounted on a chucking spigot, clamped in metal jaws, and then the switch is flicked, the 'juice' flows, and the wood begins to turn ready to be shaped. 'So it's almost like power carving really, only the wood's moving not the tool,' explains Rosemary.

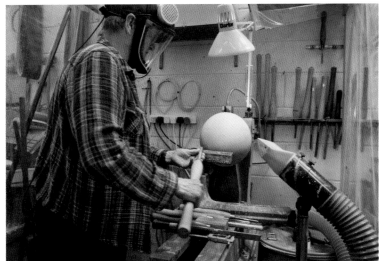

Rounded shapes are the easiest form to make on a lathe but Rosemary wanted to challenge herself: 'I got fed up with doing round things, so I started doing square things. And oblong things. And that is a bit more tricky, technique wise, because if you've got something square spinning on the lathe, you've got flying corners.' She has also made prize-winning leaf forms that involve turning separate pieces of the leaf shape in different woods, then lining them up to make a complete leaf. 'Getting them accurately lined up is actually more difficult than you might think.'

Whether to turn the wood when it's wet or to get it dried in various ways is also something that needs consideration. Rosemary explains the options:

> You can turn wet wood, and turn it very thin and then that's taken out most of the stresses that are within the wood, so as it dries there's not much resistance so you get less cracking. Whereas if you turn wet wood and leave it, if you finish turn it to about a ¼in thickness, you can get cracking.

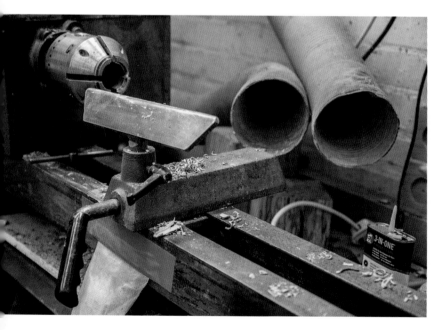

> 'So it's almost like power carving really only the wood's moving not the tool.'

Alternatively, wood can be rough turned and then dried gradually by putting it in a plastic bag, with the moisture let out every now and then over a year or two. The easiest option, but with cost implications is to buy kiln-dried wood from the merchant, and the even more expensive option is buy it ready shaped into 'bowl blanks', discs for woodturners, which can just be put straight onto the lathe. Keen DIY'ers have also been known to convert old chest freezers to use for the drying function, although Rosemary hasn't gone down that route (yet).

The Galley Hill studios are run by Milton Keynes Arts Centre. The charity also has artists' studios set in converted seventeenth-century stable blocks within the grounds of the historic Great Linford Manor House. The elegant parkland setting, thatched roof and rustic walled garden of the Great Linford studios contrast with the unadorned urban feel of Galley Hill. 'We're the beast to their beauty really,' commented Rosemary, summing up the difference. The Galley Hill district was the site of the New Town of Milton Keynes' first major housing development in 1971, and the studios located there began their life in 1974 as a community workshop. Rosemary had come across some relics from its early days: 'I think it was set up for doing up cars, because behind that sort of breezeblock wall are a load of roller doors.' Next, she says, it was turned into a community arts centre and they held classes in painting, pottery, and woodwork, with what is now her studio being one big woodwork room. Then eventually it was set up for individual artists to rent spaces in which to work.

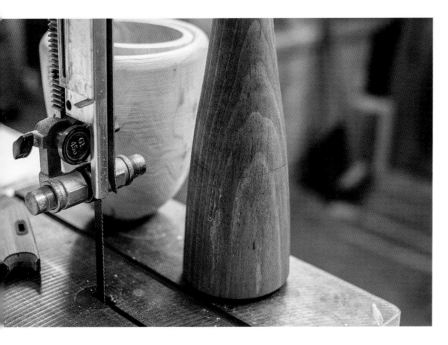

Despite arthritis in her hands, Rosemary is still keen to experiment. Most recently she has been combining pottery with woodturning, sometimes by using the wood forms as moulds for pots. Another idea is to have a go at multi-axis turning, which she says produces really interesting results. She is also interested in producing more sculptural-style work in wood, which could be achieved using this technique. 'A sculptor [Stoney Lamar] whose work I really love, he's used a lathe to turn sculptures on and he's managed that by moving the centres so there's lots of asymmetrical facets. I'd love to be able to do that. But that's quite an intellectual challenge as well,' she expands. 'There's nothing actually stopping me doing that, except, fear of something new I suppose,' she admits.

So Rosemary is still experimenting and keen to push the boundaries. Asked about what the future holds for her, she says, 'Well I hope it's going to bring new ideas, new adventures. I can't see myself not doing something creative.'

www.rosemarywright.co.uk

Making money from selling the wooden objects she makes has been a challenge for Rosemary. She became a woodturner in her forties, twenty years or so ago. During a particularly boring phase of her career as a biochemist, and inspired by a woodturning course she had attended at Great Linford, she threw caution to the wind and decided on a mid-life career change. 'Everybody says, oh they love wood, and so on. But they don't buy it,' says Rosemary with a wry laugh. Explaining why she does it anyway, she says: 'It's just so engrossing and I guess it was the challenge of getting it right and so on as well.' She does ponder on how long she will be able to continue to justify paying the rent on the studio and perhaps keeping out younger artists who might like the space to start their artistic careers.

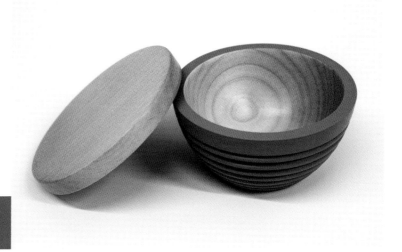

'It's a great adventure.'

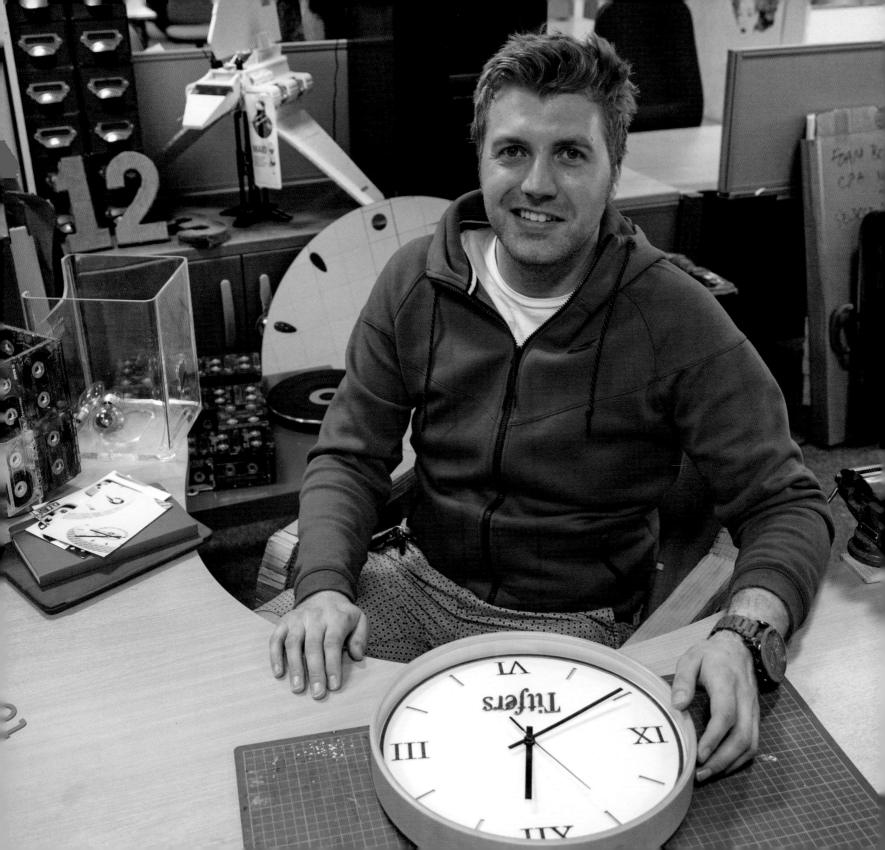

# George Hart

## CLOCK DESIGNER AND MAKER

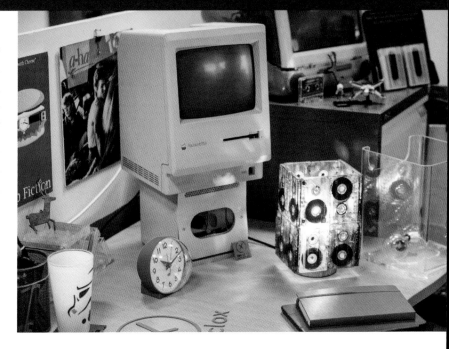

George's studio space, set in the middle of Arts Central's Norfolk House base in Central Milton Keynes, is full of technology. However, look again and it is clear that most of the technology could not be used for its original purpose. An Apple Mac Classic sits on top of a cupboard, for example, waiting its turn to be transformed from state-of-the-art 1990s design icon, to a twenty-first-century work of art. Functionality will still link the two forms, but rather than using a microchip to word process a document and dial up email, the twenty-first-century version will use a quartz mechanism to move clock hands.

Transforming an even earlier model of technology, George made a timepiece from his nan's 1970s Amstrad stereo when he was younger. That was his first experiment in clock making and a clock that he has held onto in memory of her. Another clock, currently under construction, draws on memories of his grandad who taught him to use saws and other tools: 'When I was younger, I would always go away in the summer to my grandad's and we'd always make things.' His grandad's lessons in how to strip and join electrical wires particularly inspired George to incorporate bunches of differently coloured wires in one of his clock designs. As with all of George's clocks, their stunning looks are enhanced still further when seen close up and the full extent of his creativity as a designer becomes clear when the ideas behind the components are explored. He explained that for bespoke clocks, in particular, he likes to build in the personal touch; tailoring the timepiece to the personality and lifestyle of the person he is

making it for: 'I take on elements of the person and sometimes there are memories and time captured in the clocks.'

It is not just technology chassis that George uses as a starting point for clock making. He has also taken computers to pieces and used their individual components, such as the keypad keys, as elements of his time-keeping works of art. The turntables of old vinyl record players also make excellent bases for clock faces, as the example hung on the wall opposite his studio demonstrates. Old vinyl records have been hacked up and brought from the past into present-day service. More bizarrely, obsolete bank notes, travel tickets, and news clippings, collected from his trips to New

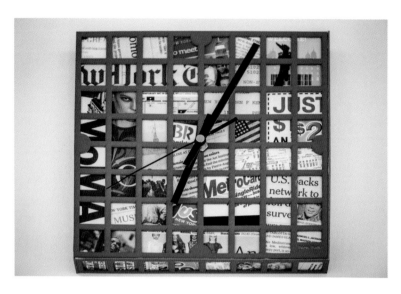

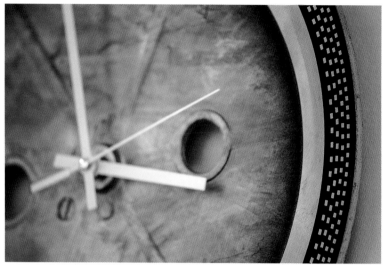

York, London and France, form the basis of design concepts incorporated into other clocks. The ticket collection clocks in particular are timepieces with a multi-dimensional feel: as well as telling the time, the tickets highlight a particular period of time in George's life.

As a maker-artist, George is always on the lookout for creative inspiration. He carries a sketchbook around everywhere to make notes and sketches or will use his phone camera to capture images of buildings, structures and unusual clocks that interest him when he is out and about. Recent trips to Poland and to Copenhagen have been particularly fruitful sources. In Poland he says it was just the different way they do their shop faces and window displays, which inspired him and he is keen to make a clock that pays homage to Lego as a result of his Danish visit.

'These pieces serve a function as timepieces but they are also a piece of art in themselves.'

Materials themselves can also be a source of inspiration. He gets most of his raw materials from eBay or car boot sales, or if he puts out a call for a specific type of item 'people hear that I need something and they give me loads of spares to upcycle'.

Milton Keynes, where he was born and has lived for most of his life, is also a source of inspiration, particularly due to its emphasis on sustainability. An early enthusiasm for cycling on the city's Redways has encouraged him to use bicycle tyres in his upcycling projects, and his frequently ripped jeans from early bike prangs have inspired the 'ripped denim' design of another clock. As a schoolboy in Milton Keynes he studied the development of the city at a young age, seeing it grow and develop, and says he is inspired by the structures such as the Point, the colours and the architecture.

At the age of 32, George had recently given up full-time work as a design lecturer at Milton Keynes College, in order to focus on his upcycled clock making. He has taken his work to craft fairs and has held an exhibition on the two floors of Gallery 200 in Milton Keynes. He is looking forward to being able to concentrate on making. 'If I'm not making and creating I get a

'If I'm not making and creating I get a bit edgy and I want to get my hands dirty.'

bit edgy and I want to get my hands dirty' so he wants more time to spend on his craft. Although he will have to rely on his other part-time work for a steady income, he says that 'I do it more for the love of it than for the money'. He acknowledges that there does seem to be a trend for buying individual bespoke items, but that it can still be difficult to sell them sometimes. Some buyers need an explanation about the amount of work that has gone into a piece before they are finally convinced to part with their money.

George is now working on his new website and wants to be ready with a set of new timepieces to sell for Christmas, as well as to approach more corporates or restaurants with the suggestion of either having a display of his work or commissioning a bespoke focal timepiece for their foyer. When asked whether he feels he will ever run out of ideas, he thinks it is unlikely. He is always getting ideas from things he takes in including exhibitions or travel. 'I'm a kind of sponge,' he says, 'I just get little snippets of information and it kind of merges together and lo and behold, I create a timepiece.'

www.toxclox.co.uk

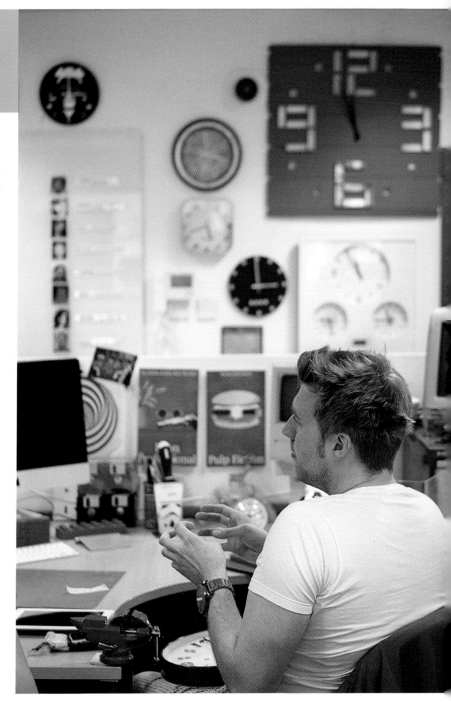

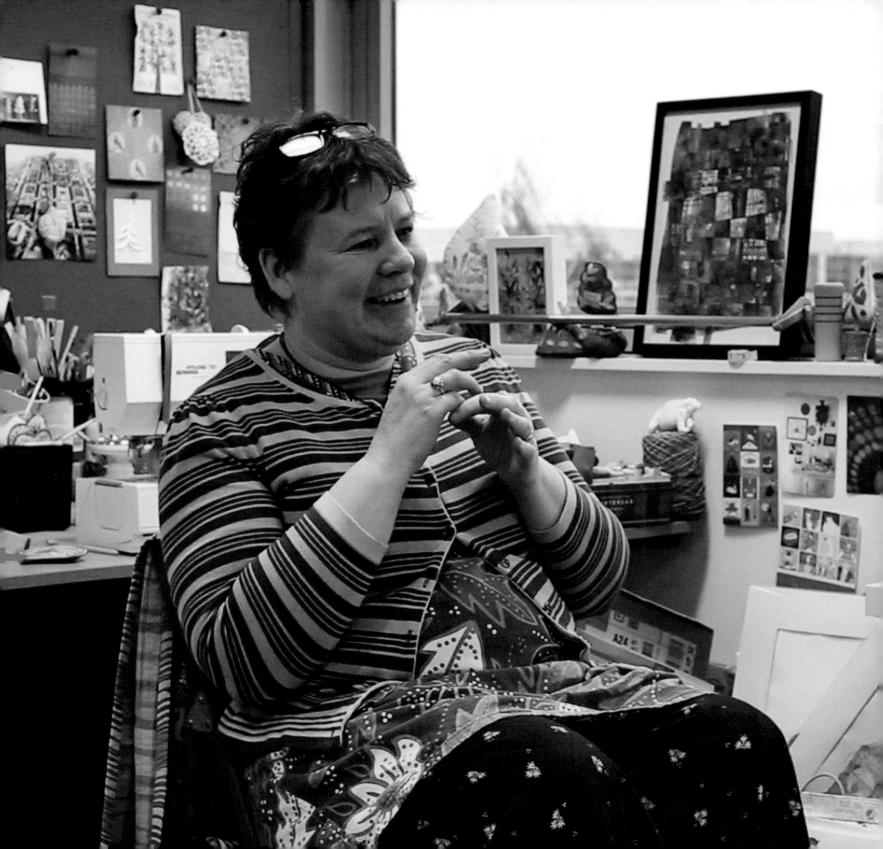

# Jane Charles

## CREATIVE TEXTILES

Surrounded by a colourful array of tiny hand-sewn decorative trees, cute pincushions, tins of threads and a scatter of beautiful fabrics awaiting taming; Jane's elegant sewing machine takes pride of place. The view through the window is of concrete and glass with the imposing dome of the Church of Christ the Cornerstone, a church where five denominations share the same space, dominating the skyline of Milton Keynes.

The majority of the things that Jane Charles makes are textile-based, i.e. working with fabrics and thread. They can be two-dimensional or three-dimensional, everything from small pin cushions, made to sell at craft fairs; to 8-metre-long quilts made with the help of schoolchildren. Jane also uses a variety of dyes and dyeing techniques to create unique fabrics. A flutter of gorgeous long silk ribbons, on which she has been experimenting with an array of pastel colours, hangs from the end of a bookcase. In order to keep the fluidity in the silk, Jane explains that she had been trying out new dyes and different ways of fixing them. Quite a faff and a challenge, she says, but worth it for the satisfaction of the end result.

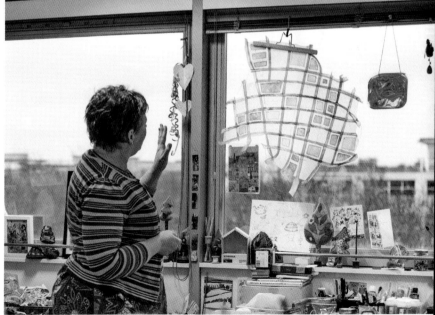

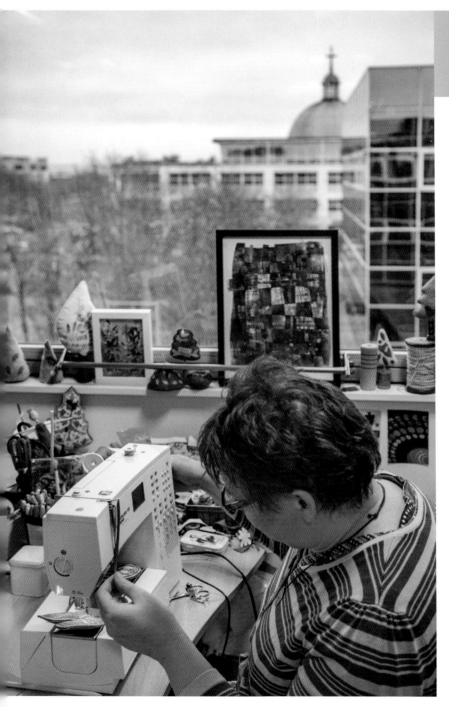

'It can overtake your life, textiles.
But in a good way.'

Jane's projects tend to be linked to people and places. Encouraging 400 children to engage with the making of the panoramic centenary quilt at a local school was another challenge. Rather than taking the easy option of just getting the children to colour fabrics with pens, Jane got them having a go at skills such as embroidery and weaving. They loved it, she says. They all got something out of it and the school ended up with a commemorative quilt, which displayed all their contributions. Jane also teaches textile techniques to adults at Milton Keynes' adult education centre, where she runs the City and Guilds course in Creative Textiles, as well as one-off courses such as indigo dyeing using shibori techniques. Another recent big project involved the learners from these courses working with MacIntyre adult learners to create an exhibition at the church we can see through the window.

In keeping with her domestic-grade sewing machine, Jane always tries to make sure that the equipment she uses in her teaching will be accessible for people to set up their own craft sessions afterwards. So the indigo dye is in a simple household-sized bucket with a lid, her learners won't need an industrial-grade sewing machine, and easy to obtain items such as string, beans and pegs play a part in the creative process. Jane is convinced that people are getting more interested in making things themselves, probably inspired by recent TV programmes, such as *The Great British Sewing Bee* and *The Great Interior Design Challenge*. It has meant that Jane has seen more people signing up for her classes as they see the benefits themselves of doing a course and actually start thinking 'ooh I could sit and embroider and have a go at things'.

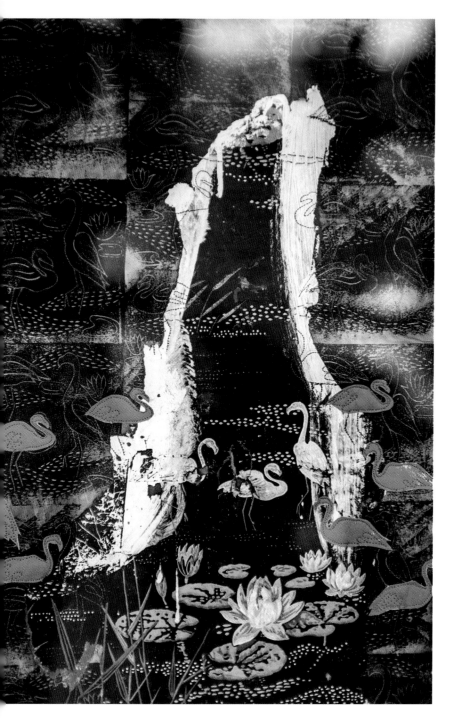

Jane herself is still learning new skills. She started off at the age of 18 by doing a Fashion and Textiles degree but didn't carry on to develop a career in that area. Now though, with her children at school, she has found that she can take the time to indulge her own textiles interests as a way of earning a living. Despite her training and experience, she still sometimes needs to get to grips with new techniques. She explains that you can start off thinking you're confident with one technique, then suddenly somebody introduces a new one: '"Oh, can you do machine embroidery on velvet?" "Oh yes." I'll Google it, and have a go and do a course and "Yes, I can do that now, thank you"'.

As well as her many links to the people of Milton Keynes, Jane is inspired by the spaces and places of the city. Her own house, a Victorian terrace in the New Bradwell area of the city, was already standing fifty years ago when the new town was beginning to be built around it. Recent renovations of the house uncovered a surviving piece of wallpaper featuring flamingos and lily pads. Jane painstakingly scraped off this piece of possibly 1940s heritage, and used it as a basis for a collage featuring the wallpaper fragment as centrepiece, surrounded by machine-embroidered flamingos and repeating prints using linocuts. She really enjoyed taking this piece of local history and creating a kind of picture about it. It's also useful as a piece that demonstrates her creative skills and techniques.

Another piece that draws on her local area is a small wall quilt where she has made use of all the little scraps, which she has collected from her teaching or experimenting. Jane explains that New Bradwell is quite susceptible to flooding and when the River Ouse comes up and bursts its banks the rivers, canals and streams flood. The piece highlights the sense of movement, partly gained from the marbling on the fabric. The Bradwell windmill features on the skyline too. Off-cut lino printing overstitched with machine embroidery also features in a stunning block print of houses in New Bradwell in moody browns and greys. 'I did

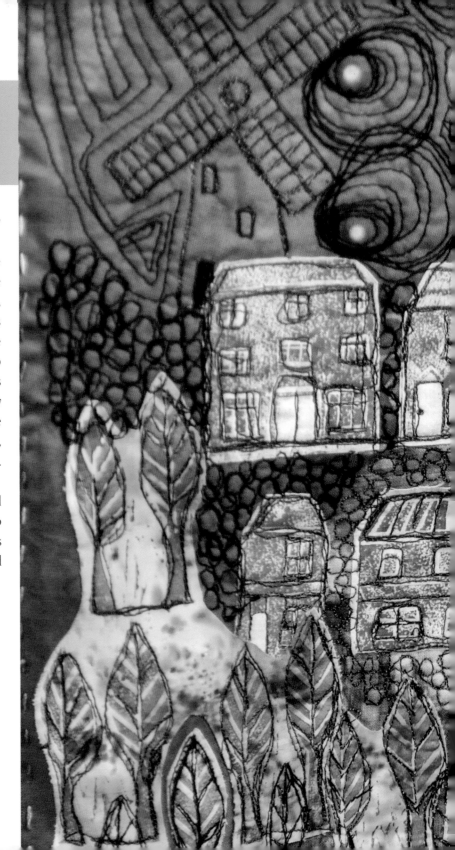

'I did enjoy taking this piece of my history in New Bradwell and actually creating a kind of picture about it.'

enjoy taking this piece of my history in New Bradwell and actually creating a kind of picture about it,' she enthuses.

The grid-like structure of Milton Keynes, a particular feature of its utopian planning, stimulated the making of a delicate translucent wall-hanging collage based on the map of the city, which looks lovely against the light of the window. The geometries of the city were also the topic of a year-long project let by Jane and a fellow maker-artist, which involved setting workshop participants with the task of taking an element of Milton Keynes and creating an A5 piece of art based on it. So one student drew on her personal relationship to the city by painting her bit of the city map on a roughly A5-sized piece of slate from Downs Barn, which she had saved from the 1970s when she first moved in. Truly a way of integrating a new city, craft and memories.

To celebrate the fiftieth birthday of Milton Keynes, Jane will be continuing to create her own stunning textiles. She also has exciting plans to encourage the people of Milton Keynes to develop their own creative skills as a way of exploring and connecting with their city.

www.smallbeans.co.uk

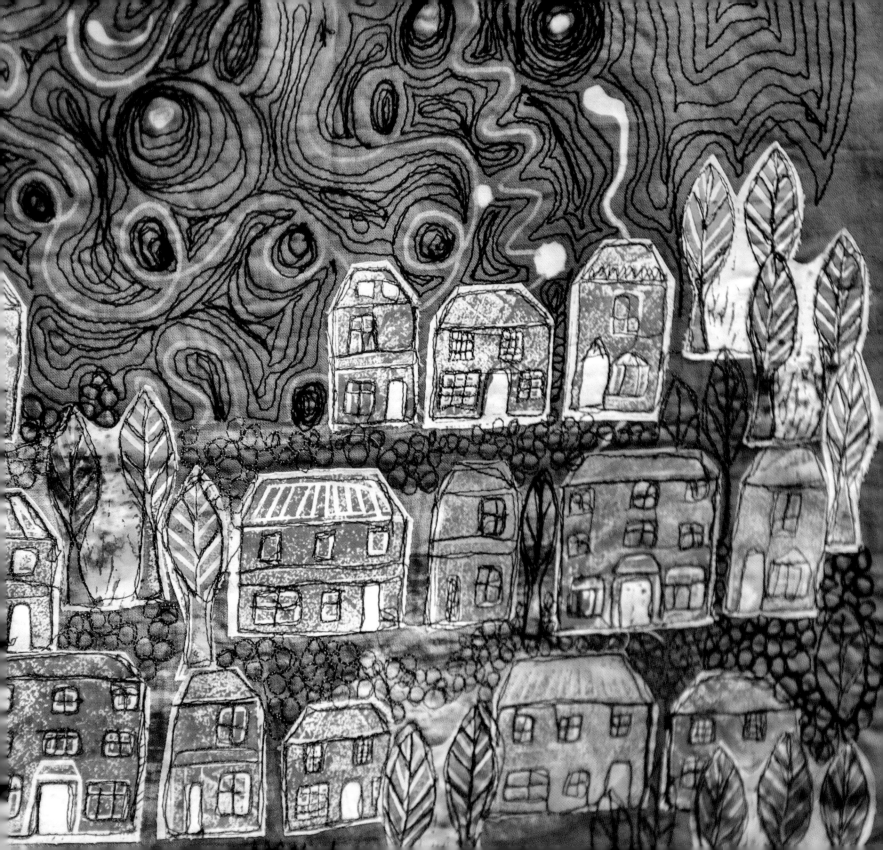

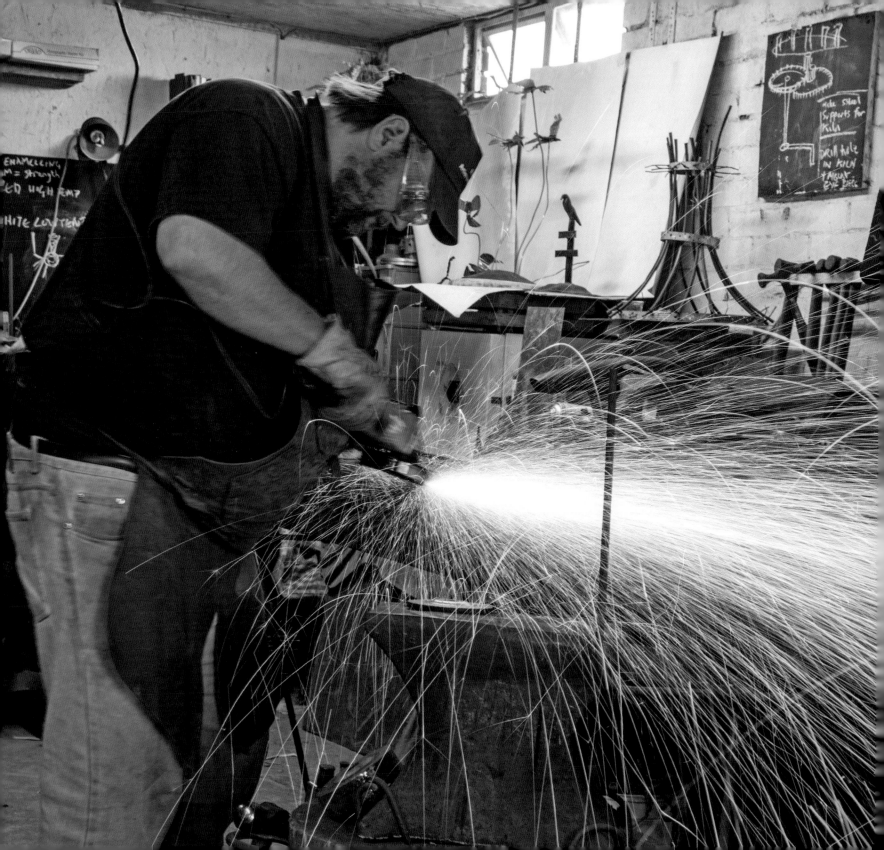

# Nicholas Packham

## ARTIST BLACKSMITH

**S**crap metal objects and strange metal forms loom up out of the depths of the extensive workshop where Nicholas creates his metal sculptures. The shelves and walls are covered with tools and pieces of metal that will later be joined together to create fantastic panthers, owls and dragons. Creating a range of work, from small pieces of jewellery to large garden sculptures, Nicholas uses traditional blacksmith skills to express his artistic imagination.

Harvey the Hare has become Nicholas's instantly recognisable mascot at his blacksmithing demonstrations at open gardens, craft fairs and festivals around the country. From his forge studio and workshop based on a farm near Bletchley he creates metal sculptures and garden ornaments to his own design and for commissioned work. After initially joining the family business as a plumber, Nicholas completed a Visual Arts degree specialising in 3D sculpture (metal and stone) at the University of Northampton. Realising that he needed resources to set up a studio he returned to work but he suffered a serious back injury. Nicholas needed two years to recover and remains disabled, requiring a walking stick to walk any distance and continuing to experience pain. Recovering as much as possible he returned to blacksmithing and art with a new determination to succeed in the area that he loves.

After working as an adult education tutor Nicholas gathered enough tools and reserves to start up his own business in 2009. He laughs as he remembers, 'that was just as the recession was coming, but I've survived it, and I've grown'. He thinks he has been particularly lucky with the tools that he has bought gradually over the years, 'It took me years whilst I was working, buying bits and pieces and then, eventually, a whole workshop turned up!'

Now in his second workshop, he is able to make larger items and has been able to create worktables at a suitable height and to organise his equipment to suit him: 'Sometimes, having disabilities hampers what you're doing. I do things in a different way, but I work within my limits.' This new, larger space has two forges, a fabrication area, storage area and main workshop. Taking on the financial commitment of a larger space is 'scary' but Nicholas is enjoying working on three or four different projects at once and is steadily expanding his business.

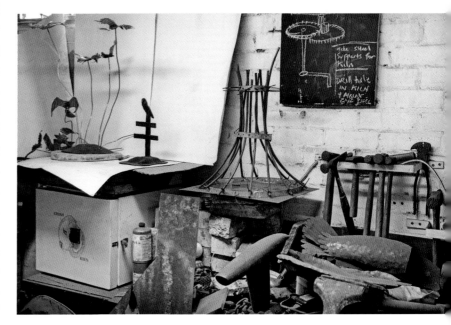

Nicholas still works with various communities, offering workshops and meeting many people through his demonstrations. He has also worked as an Artist-in-Residence at schools in Milton Keynes. The *Summerfield Angel* project was displayed at the National Gallery summer exhibition in 2011 and he is currently involved in creating a large tree sculpture with Ashbrook School. The children are designing their own leaves, and hammering them out in mini-workshops before the large tree is assembled and the individual leaves welded on to create this outdoor piece.

Working with a range of metals such as copper, brass, steel and stainless steel, Nicholas uses forging, welding, repousse and other blacksmithing skills. Whilst completing his degree he 'pestered' another blacksmith in Milton Keynes for a work experience opportunity, 'we got on well and I went back a few more times

to learn a bit more'. It was then that he 'just fell in love with working with fire; working with the fact that you could take metal and just transform it into anything that you want'. Since then he has expanded and developed his skills through practice and attending workshops, and through trial and error. He reads about technique, looks at videos of other people working on YouTube and talks to people at events. He is a member of the British Artist Blacksmiths Association and the Guild of Enamellers where other artists and craftspeople share their skills and experience.

Nicholas thinks that how artists define themselves is important: 'I'm an artist first, blacksmith second. I do blacksmithing bits, but it's part of my artwork'. He acknowledges that the blacksmithing skills have been important and doesn't mind doing repairs 'that has been useful'. That is one advantage of there being only just over a thousand blacksmiths in the country, he points out, 'whereas there are thousands and thousands of artists'. In terms of making a living he sees that as very helpful.

Creating new and larger pieces means that Nicholas now has to understand and manage the structural support aspects of his work. His most challenging piece so far is one he considers his

> 'I got taught the very rudiments of blacksmithing, and since then I've spent ten years learning how to do it.'

most successful. *The Flying Owl* now sits on the top of a 20ft-high tree stump near Aberdeen. Made of copper and with over 400 individual feathers the wingspan is huge. The logistical and engineering problems were considerable as the owl is incredibly heavy. Bars that go through hollow feet hold it up, with the claws wrapped around the branches. He strongly feels that the method of supporting any sculpture needs to suit the item itself.

Nicholas is currently working on a project where birds are flying from 5m-high poles: he is fascinated with moving sculptures and would like to achieve a swaying effect to indicate flight. He is working on the engineering calculations at present and may need to consult with a structural expert to determine the minimum size of the supporting poles for these pieces to make them 'disappear'.

Other, smaller, designs are also evolving. A new range of dragons and junk sculpture pieces of owls and other creatures are dotted around on shelves and tables, but Nicholas thinks that it is the really big outdoor pieces that he would like to work on in the future.

> 'Some of the new stuff I'm doing, the dragons, is still evolving.'

Nicholas is embracing the structural and technical challenges of making very large pieces and has strong feelings about the way that he works:

> The whole point about being an artist is you take your idea and you give it form; and you should be part of that making, because I find that whilst I'm making something new ideas are coming to mind, or the material forces me to change what I'm doing.

For Nicholas being an artist is about this relationship with the materials that he works with:

> Working with your hands in that material – it will provide something completely new. It isn't always quite how you see it, but something always manifests itself there, and you think, 'wow, look at that'. You just work with your material and it will give you something back.

www.ngp-artist-and-blacksmith.co.uk

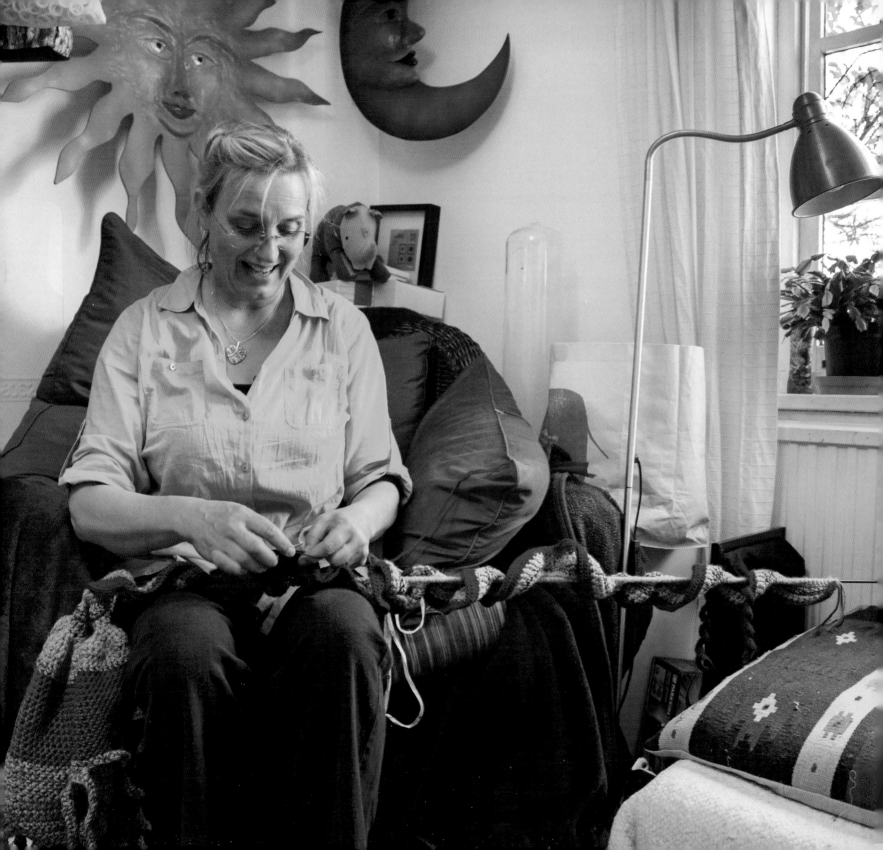

Helen's work with fabric and fibre is sculptural, abstract and substantial. In her exhibition *Accumulation* soft hangings and creations are made from crocheted wool fibre, taffeta silks, wood-framed mirrors and strings of tiny LED lights. Using warm forest colours of reds, golds, greens and browns, she dyes, crochets and sews to create objects, which break away from conventional ways of making with fabric and fibre.

Born in Australia, Helen has been in the UK for twenty-five years, and for the last ten of those she has been living right in the centre of Milton Keynes at Campbell Park. She loves the contrast between the new buildings going up, the extensive parks and the tree planting programmes, and is excited about what might be developing next in her area. Working in a studio at Westbury Arts Centre she comments, 'Coming from Australia you feel that you're in a very old house, but the city itself is new, so you've got the best of both worlds.'

Helen is fully engaged with the local community, supplementing her artist's income by providing GCSE English tuition and through running a machine-sewing class at Westbury. She teaches the group basic skills such as how to thread a machine but also stimulates creativity by encouraging new projects, dyeing fabrics and using Angelina fibre to create wall hangings. Through teaching Helen extends her own skills and comments that she learns 'just as much' as the students.

After many years as a secondary school teacher, Helen completed her Fine Art degree at the University of Northampton, a place she describes as 'thick with ideas'. Creative projects come rapidly and the themes of her work are often emotionally significant. *Accumulation* expresses the way in which she sees the patterns and shapes that she has used building up and accumulating to become something more. She begins these projects without a definitive plan, embracing change within her creative process: 'I usually start something expecting it to change and I like that. Too much planning spoils the creative process for me. It's much more exciting seeing a piece evolve.'

The work is firmly abstract yet has very specific meaning for Helen, who draws her creative energy from significant relationships. In an earlier work she reflected on her mother's life through twenty-four pieces related to twenty-four photographs;

> 'I prefer crochet when it comes to creating abstract pieces, it's more sculptural. There's something about crochet that's infinite.'

with the exact number of stitches for the days that she had lived in each one. The final piece of 12,142 stitches 'represented her life in stitches'. This accuracy and exactness within the abstract pieces is continued in the piece Helen is currently working on. She is representing her own life and the people within it through crocheted rings counting the years in colours of red, orange, blue and yellow that value and represent past and present significant others.

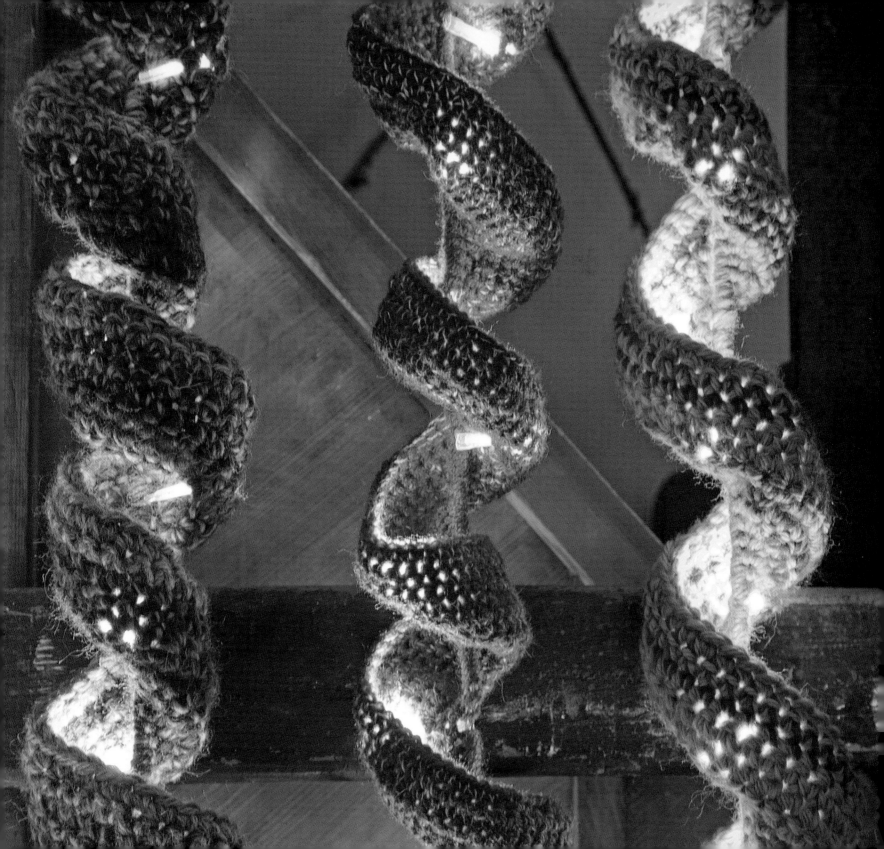

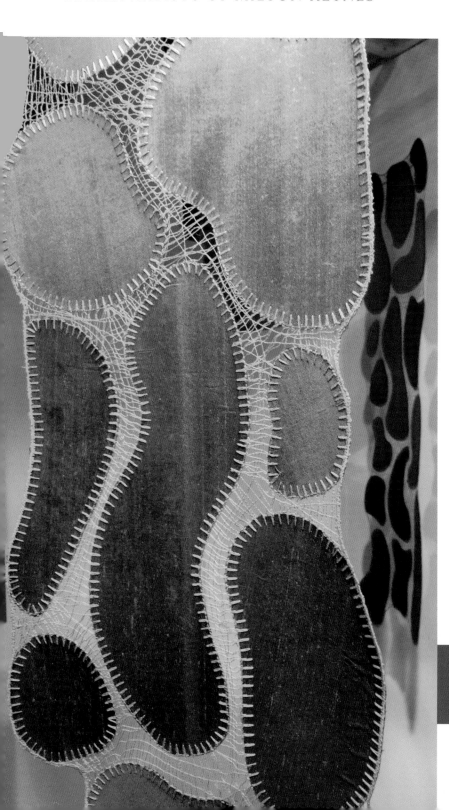

Helen is also inspired by the work of modern artists: Grayson Perry, Kandinsky's thread-like drawings and Anthony Calder's mobiles and hanging sculptures. She is excited by the work of Anish Kapoor seen at an exhibition in Rome but comments that when she looks at other people's work 'I'll go in and think "how did they do that?"', exploring how they have made it before actually appreciating the work.

In her jam-packed studio Helen also collects other people's work and objects that other artists have given her. She describes how she enjoys the fact that she can 'touch them, I can look at them and pick them up and feel the weight of them,' qualities that she is keen to reflect in her own sculptural work. Much of the room is filled with fabric samples, wool, dyes and tools that indicate the variety of work in which Helen is involved. She describes herself as coming from a family of knitters and makers of clothes and feels as if she has been making since she was born – certainly from about the age of 5 when her mother gave her boxes of coloured tissues to make clothes for her bears and dolls. From the age of 10 she was knitting jumpers and learning sewing from her family. Her family heritage of women makers remains important to her and she maintains the link to family in Australia, symbolically completing her mother's unfinished work with her sister and step-mother as she worked on her own abstract piece.

For her current project Helen has dyed carpet wool and doubled it up to crochet. It is stiff and hard, strong and heavy enough to hold its shape when hung or shaped. She also describes the tension and anxiety in using a new technique: melting away a soluble film so that material, in this case taffeta silk, with stitching around it remains, creating an airy effect in the hung pieces.

'I like to have a lot to look at,
I'm a colour person.'

These challenges form part of the creative excitement for Helen, which comes through in the way that she talks about her work with buoyant enthusiasm. Her pieces are conceptual rather than 'pretty' and she feels that she is now breaking away from conventional ways of using fabric and fibre. In some ways this involves developing the confidence to break away from making norms and traditions and just experiment, ignoring the conventions of 'how it should be done'.

Helen feels that she is only at the start of her making career and appreciates the encouragement and support from the artists around her at Westbury Arts Centre. 'I think I'm getting there, that's why I'm sticking with the crochet and getting more experimental and wilder with each new project!'

Excited by the future, she is thinking about being able to finance her 'wild' projects, which are getting bigger. She would love to take a commission where she would be free to create an installation in a really big space: 'I would love that, that would be fantastic. Yeah, that would be a challenge.'

❧

www.helendendulk.wixsite.com/fabricandfibre

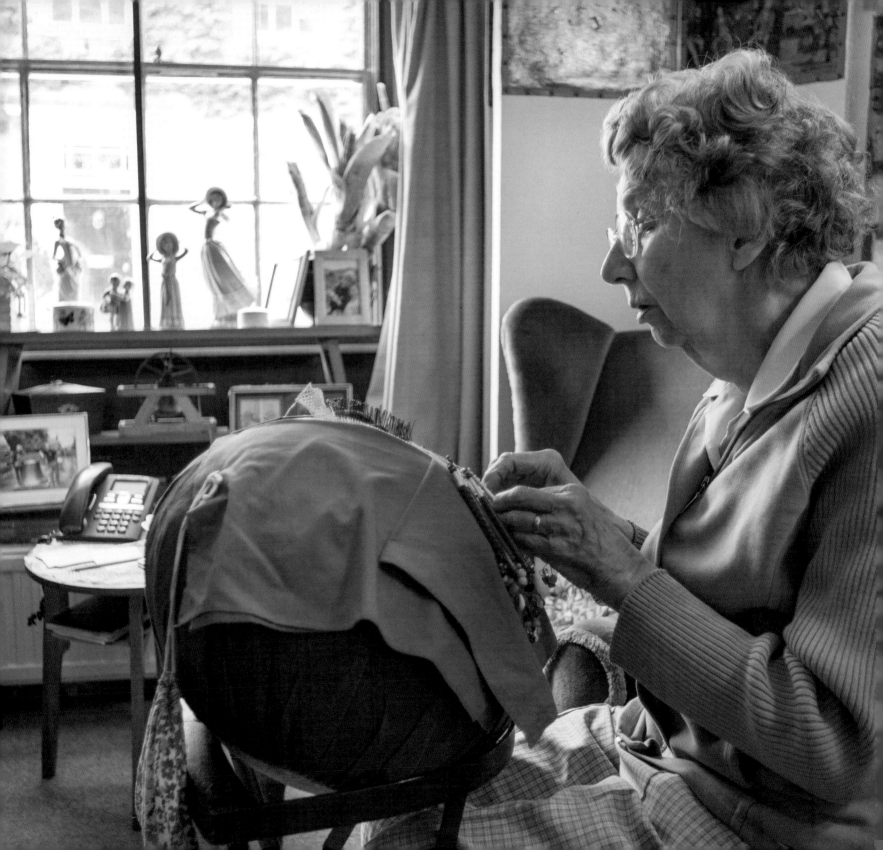

# Elizabeth Knight

## LACEMAKER

Taking up lacemaking forty years ago, when her children were small, Elizabeth helped to lead a revival of lacemaking in Olney. She is a founding member of the Olney Lace Circle, a group that now has around thirty members and meets every Wednesday afternoon. A demonstration of lightning dexterity, bobbins flying across the pillow, and a display of recently made lace confirm that Elizabeth, now in her seventies, is an expert at her craft.

The equipment needed for bobbin lacemaking is fairly minimal and compact. Elizabeth explains that cotton or linen thread is usually used, although it is also possible to use silk or wool, but not synthetic thread as that would stretch too much. A special lacemaking pillow is needed on which to work. A modern lace pillow is flat and is usually made of polystyrene, rather than hard domed straw as in the early days, so that pins can be pushed in to hold the lace stitches in place. The bobbins can be works of art in themselves and tend to be made of wood or bone; plastic ones are available but these tend to slip. Local style bobbins have lovely beads on the ends, known as spangles, to give extra weight to the threads during the making process. In the olden days, lads used to whittle bobbins from sticks out of the hedge as special presents for their sweethearts and indeed Elizabeth's husband has made her several nice bobbins in the past, and so has her son: 'I'm going to keep those, they're special,' she says.

Apart from the tools to make lace, a pattern is needed as a guide to how to twist the threads to make stitches. A cover cloth to keep the lace clean as it is made is also useful. Elizabeth rests

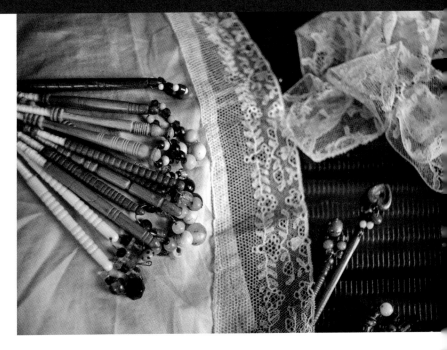

'Lacemaking is a big part of the heritage of this area.'

her pillow on a wooden 'horse' or 'maid' in front of her chair so that it is at the right height. A magnifying glass may also be used to help with the very fine stitches.

The work of Elizabeth and her fellow Lace Circle members can be seen displayed across the town of Olney, in North Buckinghamshire, now part of the Unitary Authority of Milton

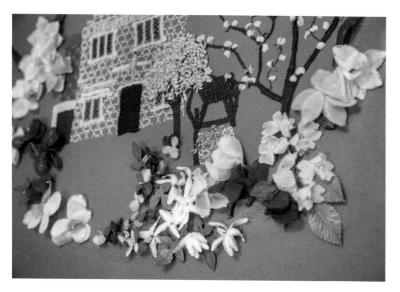

Keynes. A visit to the Cowper and Newton Museum in the Market Place reveals a gorgeous set of lace collages made by members of the Lace Circle hanging on the wall halfway up the stairs. The design of four views draws on Olney's surroundings for inspiration. One view looks across towards the parish church of St Peter and St Paul from nearby Emberton Park; another looks across the Market Place towards the Bull Inn; while a third scene shows the Cowpers oak tree, which used to be in Yardley Chase. The final scene is of the lace factory in Olney High Street, built in 1928, from where lace was distributed until the Second World War.

Elizabeth and her fellow Lace Circle members, along with other Olney craft groups, also contributed to the enormous textile-based town map hanging in the community centre. Their contribution was to make Milanese lace to represent the River Ouse, which runs through the town 'though it was never as blue as the thread we used', she comments with amusement. Another Lace Circle project, currently underway, depicts a poppy field, and Elizabeth hopes that this might find a home with a local British Legion social club.

This integration with the local community runs right through Elizabeth's lacemaking, from making special pieces for local projects, to making presents for local friends and relations. The leader of the Olney Lace Circle, Lesley Hanlon, designs original lace patterns. Elizabeth explains that 'she usually gives us a pattern as a little present at Christmas, with a card, and it's usually a bookmark or something fairly small that will fit inside a card, but they can be quite a challenge sometimes'.

Elizabeth's lacemaking links her in many interesting ways to the past as well as to the future. Her father-in-law built the lace factory for the last lace dealer in Olney, Harry Armstrong, and she is extremely knowledgeable about the history of lacemaking in the town and surrounding area, which dates back to the 1500s. 'Lacemaking is a big part of the heritage of this area,' she says.

Looking to the family, making a lace-edged handkerchief for her son's bride to carry on their wedding day gave her great pleasure recently. She was very impressed when her sons had a go at lacemaking when they were younger – 'and they picked it up virtually overnight and I was so jealous', she confides with a smile. Her young granddaughter has also shown interest in lacemaking

and has already put in a request to inherit her Grandma's lace pillow, laughs Elizabeth. Elizabeth's own mother didn't really take to lacemaking though, she says, so all her skills have been picked up from local teachers or on special courses.

Lacemaking links Elizabeth to beyond Olney too, as the craft has national and international fans. She has demonstrated her skills at Middleton Hall in Milton Keynes' shopping centre, as well as at the Milton Keynes Arts Centre at Great Linford. She attends lace days in the local area, which brings lacemakers together with teachers, suppliers and historians. She travelled far and wide, from Scotland down to Penzance, when she used to run a lace supplies business with her husband and she has also demonstrated lacemaking in America and New Zealand. She likes to visit places such as Honiton in Devon where exceptionally fine lace is made: 'It's beautiful, I can really appreciate the work that's gone into those pieces.' In addition she has a claim to fame as Ruth Goodman's lacemaking teacher for the BBC's *Victorian Farm*, although unfortunately she herself didn't make it onto the small screen. It was a great experience though, she enthuses, and it 'gave me two marvellous days of memories'. Elizabeth also spreads the word about the pleasures and history of lacemaking by giving talks and demonstrations in local schools and to local groups, usually women's groups, WIs or church groups.

Elizabeth shows no signs of giving up lacemaking and is still keen to try out new techniques. Her only worry is the challenge of keeping lacemaking going, as the Newport Pagnell lacemaking group has recently folded. 'We need youngsters and younger adults to come and have a go, we really do,' she concluded.

www.olneylacecircle.co.uk

'When you're making lace, you just concentrate on what you're doing and you forget all your other worries.'

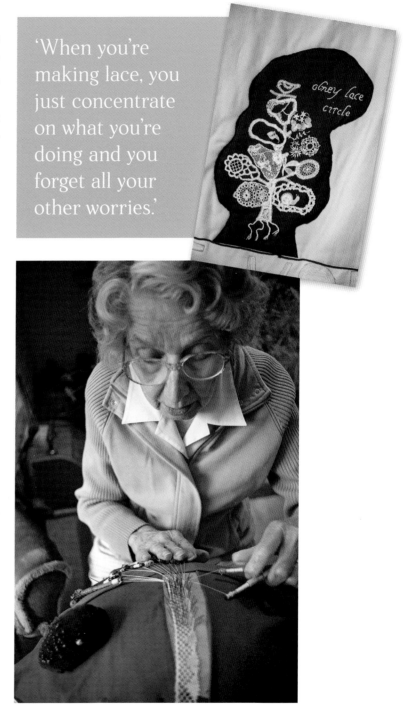

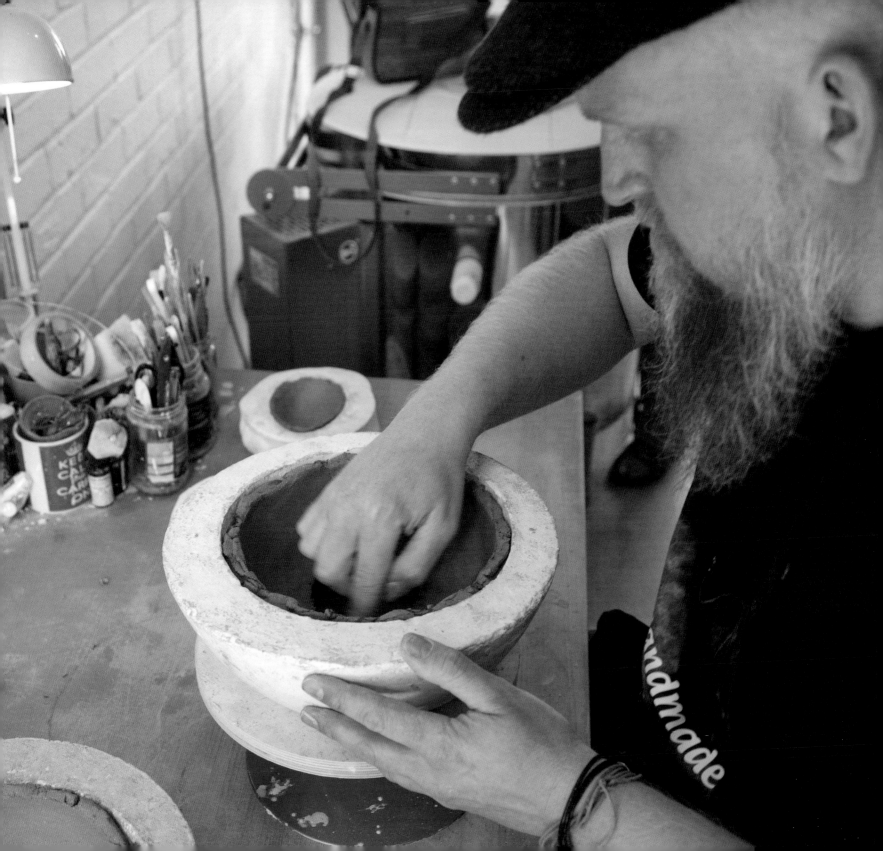

# Andrew Macdermott

## HAND-BUILT POTTERY

ools, mountains and the houses of Iceland are reflected in Andrew's hand-built and slip-cast work. In matt stony blues, whites, blacks and greys he uses a range of glazes to capture the landscape that inspires him. Jagged mountains swirl around the skylines of bowls, which hold blue/green pools of glaze, and Lopi wool threads through holes in pillow vases are reminiscent of this beautiful volcanic world.

Andrew has lived in Milton Keynes for most of his adult life. His knowledge of the city and his extensive network of contacts with its communities developed during his career as a community worker – but three years ago Andrew left his full-time job and career and started his independent business as a studio potter. He became passionate about pottery following a one-day workshop at Milton Keynes Arts Centre. He then took pottery evening classes there and fell in love with ceramics. 'Over a period of months I cleaned out my garage. I got a little hobby kiln, second hand. I just had a little worktable, and this chair, and it was just something that took over.'

After selling his work at weekend craft fairs he took the decision to become a full-time potter. 'It was quite a nerve-wracking thing to do. I had two strengths to what I was doing, one was working with schools and communities and the other was making and selling.'

These two strands are still key elements of Andrew's business and he is keen that the teaching and workshops that he offers focus on community engagement and the social side of pottery making. 'It's about bringing new people together who've not tried

an arts skill before, but also to get them to meet other people. I really enjoy that part of it.'

A project with a local school involved creating a series of ceramic flowers which would represent the child's family, their journey and the country that they come from. They now hang on white branches along the school wall alongside photographs of the children making them. Andrew is now involved in another school project with children shaping clay hands to represent school values: 'to represent trust, or compassion, and even reverence. Quite a strong theme for Year 6, and they've really taken to it quite well.' He expresses deep satisfaction with the joy of discovery that is experienced by both children and adults creating their own objects out of clay: 'It's a lovely thing to witness and to be part of.'

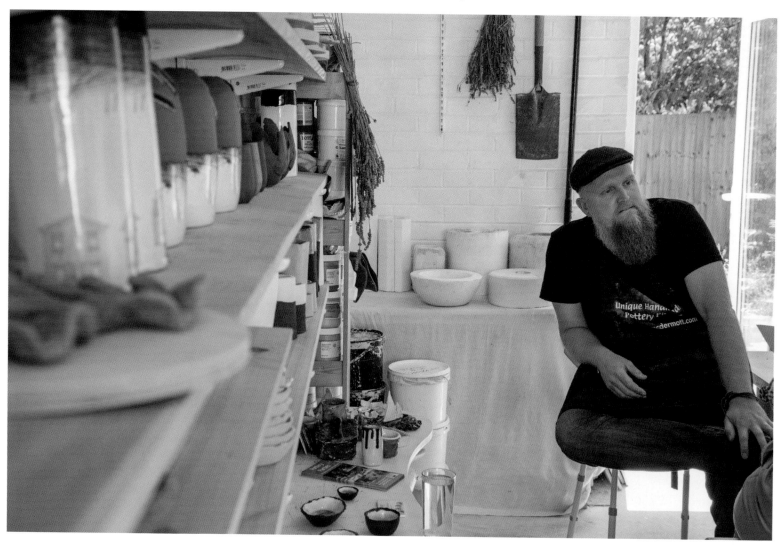

'I was lucky enough to visit Iceland, and I try and capture what I saw in the landscape there.'

Developing the work with schools and communities required the purchase of two new and larger electric kilns and a van to transport clay, pottery tools and the work to and fro. Looking after the precious creations of others has its anxieties. 'Even now, after three years, I'm still scared every moment that I either take something out of the kiln, or I transport it across the city. Accidents can happen ...'

Getting the balance right between making and selling his own work and the community engagement side of the business is important as the biggest challenge has been generating a regular income stream – making enough money to survive but also to be creative.

Andrew's own work is inspired by the volcanoes, hot springs and colours of Iceland. He visited the country in early 2013 and was blown away, taking 'thousands' of pictures. He immediately wanted to recapture what he had seen in his pottery and set about developing a range of bowls and dishes: 'I just thought about how I could recreate an aerial view of the hot springs.' Using a rough, gritty clay to create a textured external surface, Andrew hand-builds the bowls using a mould. The water effect is created through melting glass: 'I literally got some old blue glass that I found, an old bottle, and I broke the glass up and melted it in the kiln in the centre of a bowl and it just looked amazing.'

'Melted old blue glass has a kind of residue around the edge that looks like the minerals that I saw in the hot spring areas.'

The bowls are glazed in a range of blacks, greys, whites and blues, often in a matt rather than shiny finish. The reflections are all from the pooled 'water' at the bottom of the pot.

Taller, cylindrical vases have delicate drawings of Icelandic buildings, houses and churches, with a high skyline in the same glazing tones. For these Andrew uses a process called 'decal' to transfer the images onto the clay. His more recent work uses the slip-casting process to create pillow vases. These smooth oval forms are created by pouring liquid clay into moulds, the excess is poured away and the clay left to dry for a few hours. Then 'there's that magical –or not so magical, if it doesn't work – moment when you crack open your two pieces and you're left with this lovely shape'. These vases are marked with the 'crazy skyline' using black lines at the border between the matt glaze and the white body of the piece. Some pillow vases are perforated with a few small holes and Icelandic Lopi wool is sewn into them adding yet more texture and tone. Three years into this work Andrew continues to find inspiration and new ideas from his pictures and memories of Iceland.

Andrew's joy in his work and the connection between landscape and pottery continues back home and on his travels across the UK. Visits to Pembrokeshire and Durdle Door in Dorset have inspired him too. 'I've actually left pieces of my pottery in these places as well,

just as little pieces of art abandonment, which is quite a fun thing to do.' This fits with his personal philosophy as he acknowledges that in terms of his own work he is only able to sell in certain communities, but counterbalances that with his community engagement work and enabling people to make their own items.

Andrew reflects that he doesn't think of himself as an artist, 'just a potter, and maybe a community worker, an ambassador of some kind', encouraging people to 'have a go'. His vision is to have a bigger studio, perhaps his own arts centre, to deliver community work and to pass on his own learning and enthusiasm to others, who in turn will become teachers themselves. He adds that it is especially important in Milton Keynes for people to see something different, more locally made, alongside the commercial centre and for all kinds of art and artists to have a higher profile.

Becoming a potter has meant that Andrew has become more open about what he produces and hopes to achieve. He remembers that at first 'putting my work out to the public was like feeling naked'. Now he has the confidence to move on, to try new ideas and is invigorated by the work that he does. He hopes others will be too.

www.andrewmacdermott.com

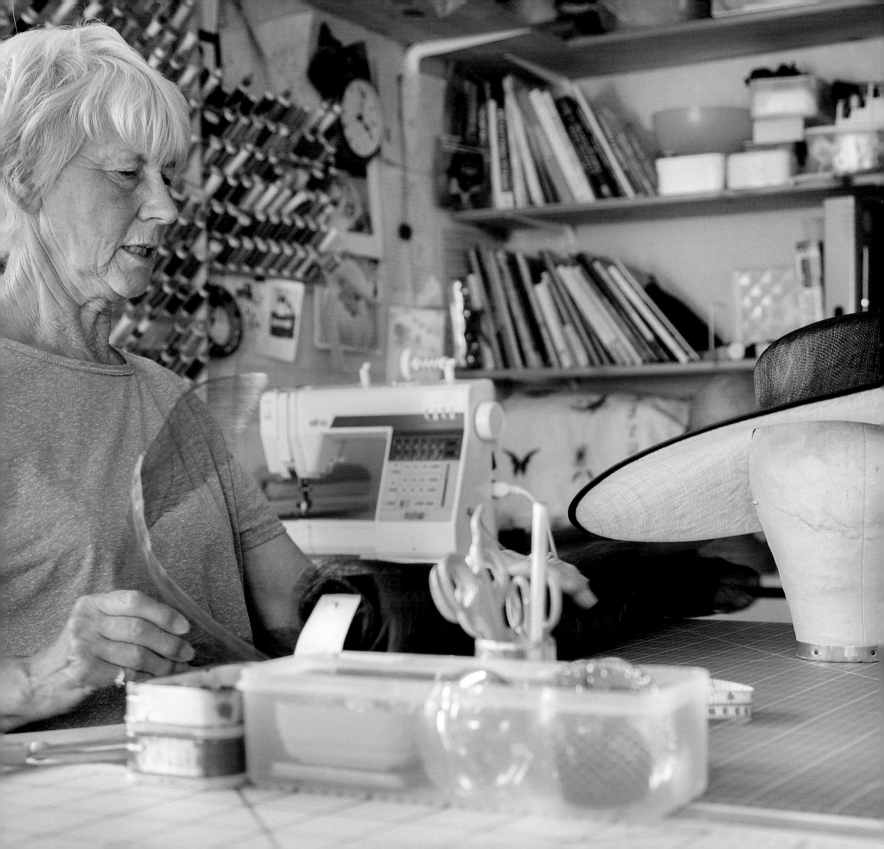

# Gillian Hughes

## MILLINER

So many options for topping off that special outfit! Gillian sits in her showroom surrounded by hats big and small, in a multitude of vibrant and muted colours, many trimmed with fabulous feathers, velvety velour or glinting jewels. To add to the diversity of choice there is also a sparkling selection of tiaras and headbands, as well as a range of saucy fascinators.

There is a lot more to making hats than meets the eye. Gillian explains that the first stage in the birth of a hat is blocking. A specialist based in Luton, a town long famed for its hat-making heritage, blocks the hats that Gillian uses as the base for her designs. Each crown or brim of a hat is individually blocked by hand on either a wooden or an aluminium block. Heat and steam are used to give them shape, as determined by current fashions. Then, keeping in mind the tastes of her customers, Gillian selects the crown and brim she would like to be joined together. Her customers might not realise that they are also actually buying a piece of history too: 'the chap that blocks for me is actually a fifth generation milliner, so they've been blocking in Luton for many, many years and it's quite an experience to go there,' she says. Although Luton's hat making has declined since its peak in the 1930s there are still many milliners in the town, often in converted terraced houses.

So the bare hat, beautifully packaged and pristine, arrives at Gillian's workroom ready for her to transform it into a desirable and wearable art form. A range of fabrics can be used by her to colour the hat, including velour, silk, felt, or Sinamay (a lovely airy mesh-style fabric woven from the stalks of the abaca tree). Next comes the trim. All sorts of different feathers may be used, although none from birds farmed purely for their feathers. They vary from strikingly bold to softly delicate. Some have been dyed to match or contrast with the fabric base; others are kept as they are for their natural beauty. Gillian also handmakes silk flowers to adorn some of her hats, or uses veiling to add character, or Swarovski crystals to add sparkle. Handmaking the accessories stemmed from not being able to source exactly what she needed: 'If I can't find what I want, I'm the kind of person, I guess, that will just try and make it.' Sometimes you need to just take the plunge and experiment she explains:

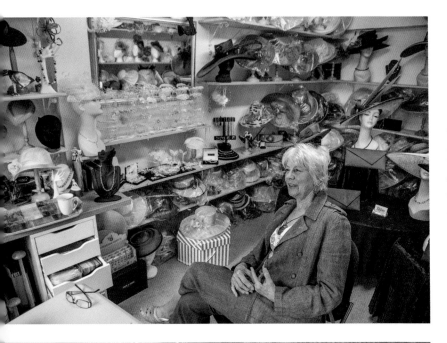

It's like making those flowers there. I thought the only way I can ever manipulate the velour is going to be soaking it in water. I didn't know what it would do if I did do that, but I cut a round of petals out and soaked it in water and to my joy, it worked.

Up in her workroom, overlooking the playing fields of Newport Pagnell, Gillian has a vast range of equipment to enable her to accomplish her creative transformations. A fan of Elna sewing machines since her job many years ago as a demonstrator in the Milton Keynes branch of the John Lewis department store, Gillian has a standard sewing machine, an embroidery machine, an embellisher and an overlocker. 'It's very important that you have a good machine,' she comments. The drawers are full of silks and crystals, feathers and threads, and lots of different kinds of needles, as each different kind of fabric needs a different kind of needle. She likes to get inspiration from nature, as well as from other milliners, such as Philip Treacy: 'I'm very much watching what other milliners are doing and the trends, and I don't ever want to be left behind on that.'

  As well as the practical challenges of designing and making the hats, Gillian enjoys the psychological challenges of making sure that the customers end up with the perfect top-off for their special occasion outfits. This can range from coaxing a shy mother of the bride, who thinks she would rather fade into the background, than dress for herself; to taking four hours to make sure that every one of a fun-loving set of seven wedding guests ended up with the perfect titfer.

'If I can't find what I want, I'm the kind of person, I guess, that will just try and make it.'

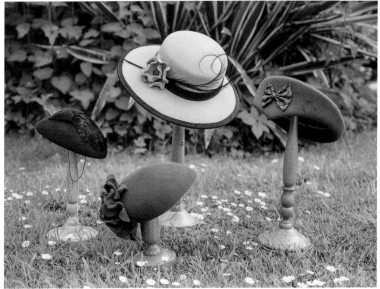

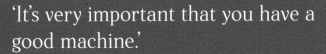

'It's very important that you have a good machine.'

Gillian also uses her skills to raise money for Cancer Research in memory of her brother. This involves giving talks at local women's groups such as the Inner Wheel or the WI. She will talk a little about the history of hats, then about how to wear them, something that many people are not sure about. Then the audience participation begins, using a combination of psychology, an eye for design, and humour. 'I get two volunteers up and I've learnt that I don't ask for the volunteers, I ask the rest of the ladies to get the tallest and the shortest lady to come up.' Gillian can then demonstrate how, if she puts a big hat on a tall lady, 'wonderful'. Then she puts that same big hat on the short lady and 'you can't find her, it's wearing her'. And the little hat that the short lady had had on, she puts on the big lady: 'didn't do anything.'

Gillian has lived in Newport Pagnell, part of the borough of Milton Keynes, for many years and loves the opportunities the city provides: 'I think Milton Keynes is absolutely fabulous because it's so diverse. There's so many different things going on and I think it's an amazing place, I really do.'

She also remembers when Newport was featured on national TV at the time of William and Kate's royal wedding where she was included in the write-up. She had made a hat which was worn by one of the wedding guests, while local parchment makers William Cowley supplied the vellum for the marriage certificate and the happy couple drove away in a car by local maker Aston Martin. A starring role for 'little old Newport Pagnell' and centre stage for hat making!

www.titfers.com

# Elaine Mckenzie

## DOLL-MAKER AND PAINTER

A striking self-portrait dominates Elaine's studio space. She had painted it the day before to celebrate her fifty-fifth birthday and is proud of the result. The portrait is really part of her aim of 'digging deeper' into herself since she moved to Milton Keynes, from London, around two years ago. Also dotted around her studio are several groups of intriguing textile dolls, which she has recently made.

Making the dolls has developed organically for Elaine. It wasn't something she particularly planned from the start. One day, with some material to hand, she just thought, 'I'm going to make a doll for myself. I can make a doll and I can pretend it's for my niece, just in case people say things to me, like, "Oh why are you making dolls?"' She decided to start by making 'a doll that looks like me, a brown doll', followed by making other dolls to reflect her world. Her friends came round to visit and one wanted to take these first two dolls home to live with her. So Elaine was prompted to make some more dolls to replace them, this time using recycled materials such as one of her old jumpers.

> 'I think there's more to me making the dolls than meets the eye. I found that I was putting a lot of my own emotions into it.'

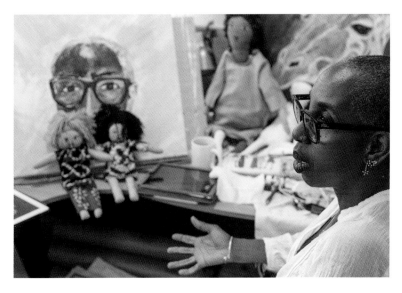

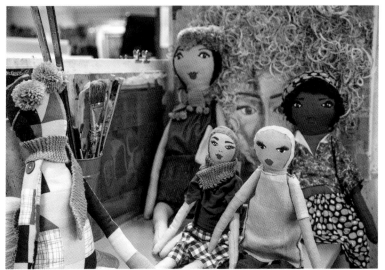

'Just because you're an adult you never stop playing, but I think the world makes you think that you should stop playing.'

Although, as well as giving dolls out 'on loan,' she has informally sold a couple of her dolls to fellow artists, Elaine does not offer the dolls for sale at the moment. Instead, she thinks that she is using them to explore her own emotions, almost as a kind of healing. She finds it interesting that visitors to her space tend to home in on one particular doll, 'Oh, that's the one I like'. Wondering about why people choose a certain doll, Elaine muses that they may like a doll because of its characteristics such as having afro hair or curly hair or maybe because of the personality the doll appears to present. It might not necessarily be about the doll looking like them but about something more subliminal than that, perhaps enabling people to express something about themselves, which society had made them suppress.

People also make unexpected choices too, such as her 8-year-old daughter choosing to use red checked material for the hair of a doll which Elaine helped her to make, rather than the perhaps more obvious wool. She feels that the concept of her doll making is 'about playing and kind of digging a bit deeper into myself'. For the moment she will keep the dolls 'not because I'm a hoarder, but because I think they've all got something to say at the moment'. She joined other local artists at the Church of Christ the Cornerstone exhibition space during the 2016 Bucks

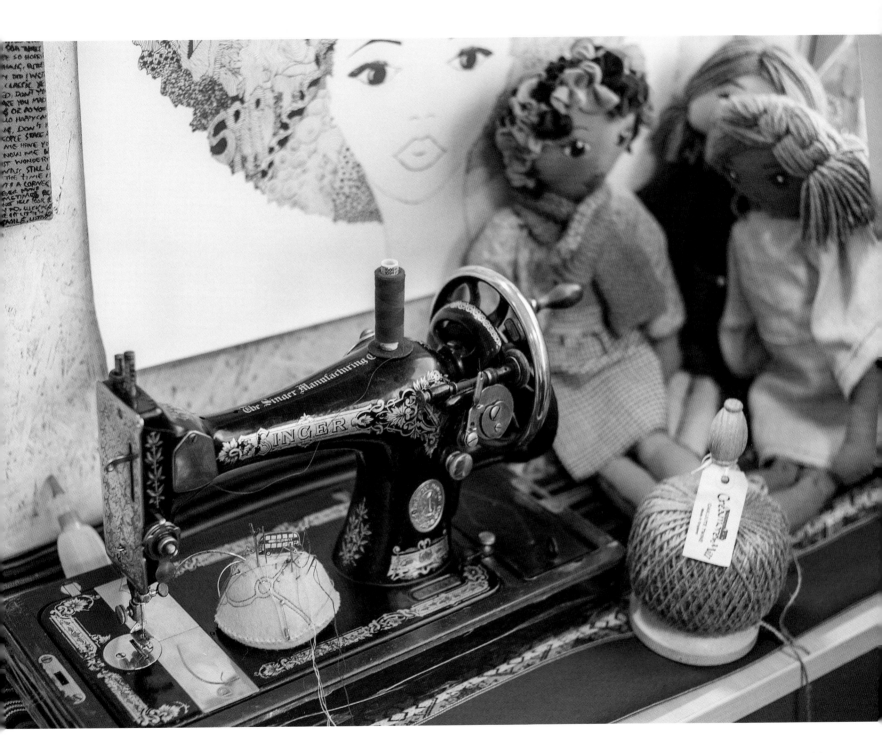

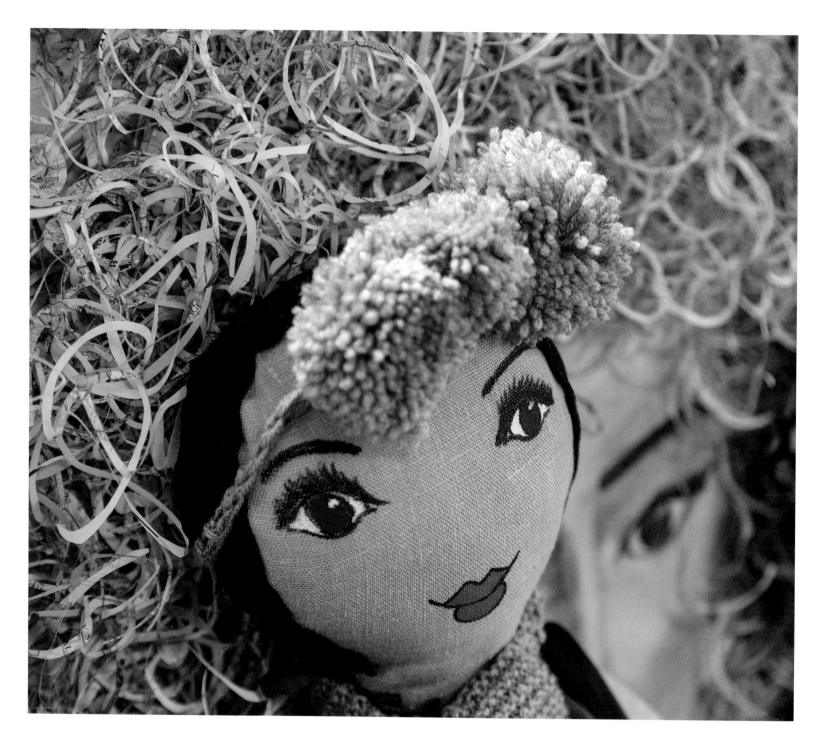

Open Studios, creating an engaging, playful, montage of her dolls for the opening night.

Two sewing machines sit within Elaine's studio space, and she has another one, a sophisticated Pfaff, at home. She recently oiled and reconditioned the gorgeous ebony coloured, brass engraved, antique Singer sewing machine, which is surrounded by dolls on one table. On her main worktable is an IKEA machine, which 'cost me all of fifty quid and is brilliant'. This is the machine that she has used to make most of her dolls. She also hand-stitches an interesting button onto each of the dolls' shoulders as a signature, and to give them a more finished look. Elaine says that she feels more peaceful making the dolls than she does when she is painting. She explains: 'When you're making something, you have the ideas in your head and you can look at it from afar and think, I like this. Whereas a picture you can think, that doesn't look like me, I don't like it.'

Elaine's career has been varied. Despite her Art A Level, her Jamaican-born Mum persuaded her that typing and office practice was a more reliable path to follow in her youth. After a few years of office work she trained as a hairdresser, partly for its creative potential and partly because she loved chatting to people. She also carried on with art in some description alongside these options. Then in her late forties, alongside several other older women who were also exploring their creativity, she signed up for an Art Foundation Course at Morley College, London, getting a distinction in textiles. During the course she engaged in all sorts of art, including painting, drawing, stitching and knitting, and lino cutting.

Moving to Milton Keynes has given Elaine the opportunity to further explore her artistic talents. She took studio space at Arts Central in its location above the railway station and then moved with the organisation to its Norfolk House location. She enjoys the way that, at Arts Central, 'we all encourage each other'. She lives in one of Milton Keynes' newest gated developments set within Netherfield, one of the original Milton Keynes grid squares, which was designed in the 1970s, she has heard, by 'cool studenty architects'. Although drawn to the older style 'crunchy caffs' of Stony Stratford and Newport Pagnell, she really likes her new residence with her allotment located just across the road. 'I'm beginning to like Milton Keynes now,' she says, 'the fact that there's a body of artists and there is a lot of creativity here, and it's quite underground, if that makes sense.' She does, however, suggest that the buildings could be jazzed up a bit with colour or mosaics and is hoping that even more active creatives move in as the city expands.

There are so many good artists around these days, says Elaine. The Nigerian artist Yinka Shonibare has particularly inspired her as she likes the way he listens to a passion and follows it through. She also follows the Instagram account of her friend Paul, a London-based artist, who posts photographs that look at the nitty-gritty of Camberwell life, commenting that he has 'just made amazing art out of that, it's just brilliant'.

Elaine's dolls will probably be what occupies her for now. She might perhaps develop the concept by encouraging others to use doll making to explore what is going on their heads, as she is doing herself. For the moment, the green spaces of Milton Keynes are providing her with an amazing context within which to pursue her creativity.

www.laynearts.com

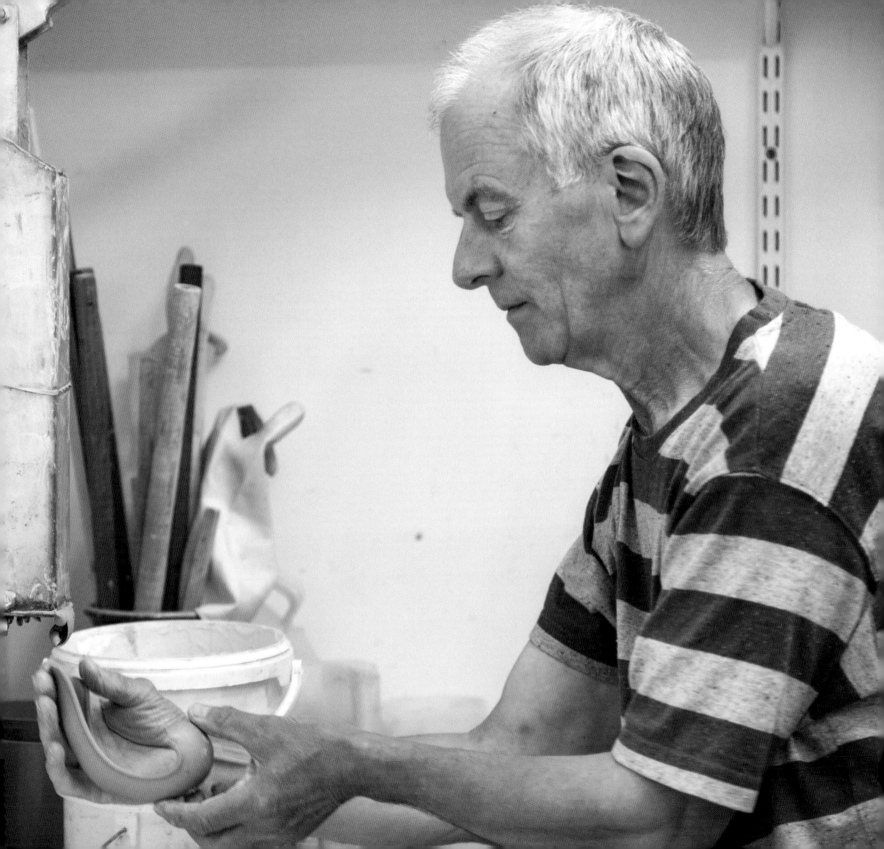

# Mark Compton

## SODA-FIRED CERAMICS

**M**ark creates soda-fired ceramics with rich and decorative surface qualities. His signature pieces are rocking jugs and teapots in rich blues, tans and browns with intricate and precise surface patterns. Using techniques and skills developed over many years, Mark loves the process of making and the beauty of the soft tones and orange peel effects that characterise his work.

A visit to the potteries in Stoke-on-Trent whilst still at school first got Mark hooked on pottery. He recalls that seeing the factories in their heyday: the different processes, the types of clay,

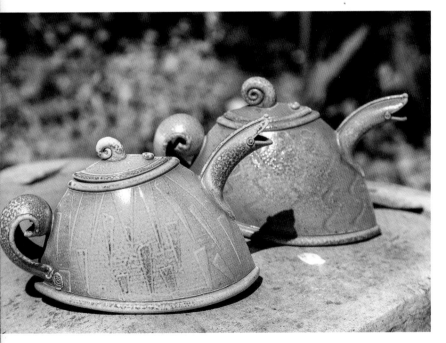

the mixing of glazes and the firing of big kilns was a 'fantastic experience, it was just incredible!' After completing a degree in Ceramics at the Epsom School of Art and Design Mark developed his throwing skills as a production potter, throwing pots all day on the wheel for a local pottery, a route now rarely available for those hoping to develop their skills as ceramics practitioners today. After about a year Mark set up his own studio and built his first kiln. He 'learnt a lot from that time'. Later he returned to full-time education to embark upon an MA in Ceramics at Cardiff Institute of Higher Education. The lecturers and makers that he met there continue to inspire him: Geoffrey Swindell's miniatures, Wally Keeler and Mick Casson, all potters working with salt and soda firing. Mark describes his own ideas as coming slowly, through looking at things he likes and enjoys. He has a fondness for engineering and all things mechanical and loves looking at how old aeroplanes and old motorbikes are put together. He takes photographs and makes little sketches of these and many other things but adds that his influences are very varied. 'I don't think that you necessarily consciously think "Oh, I'm going to make a pot that shape, so it looks like an aeroplane wing," but I think that these influences just slowly filter through.'

Mark's studio for the last eight years or so has been in the old barn at Westbury Arts Centre. At the time the abandoned barn was filled with junk but Mark took up the challenge of being offered a space there and built internal walls, put in plumbing and electrics and turned some of the space into a studio. In the last couple of years he, and fellow potter at Westbury Arts Centre,

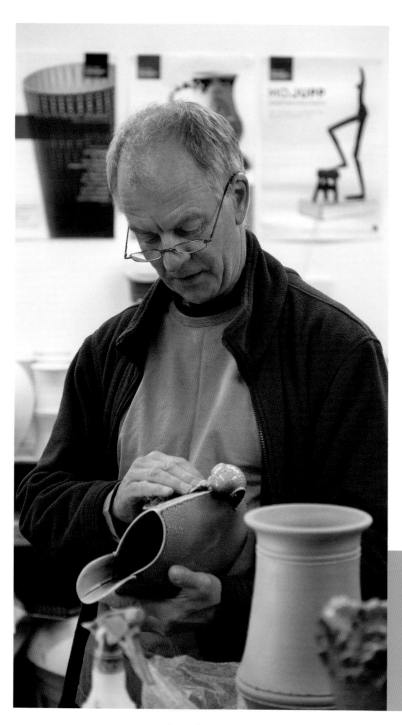

Kirsteen Holuj have built a soda-fired kiln in the grounds, which is now firing successfully and providing a new body of work.

The process of soda firing is both technical and elemental. The pots are first biscuit fired, an initial firing, which drives off all the water and chemically changes the clay. Pots are then decorated in a variety of ways using coloured slips and oxides before being loaded into the large soda kiln for the glaze firing. The entrance is then bricked up. Two large gas burners fire the kiln and soda is added when it has reached 1,260°C. The soda vaporises at this high temperature and builds up a layer of glaze on the pots. The whole firing process takes about twelve hours and introducing the soda takes place over two to three hours. The kiln is then cooled for twenty-four hours before it can be 'unbricked' and the newly coloured pots revealed. Soda glaze itself is a pure transparent glaze, however, the different colours, often blue, are achieved with the coloured slips that are put on before the pot goes into the kiln.

Mark's thoughtful, reflective and technical approach to making is evident in the complex shapes that he creates: the rocking jugs, the dynamic teapots, which are often miniatures, and the subtle sprigged decoration added to the larger pots. Although an expert at the potter's wheel Mark enjoys all forms of making. His rocking jugs are hand built: 'A fairly simple technique, but it can be quite tricky to actually work successfully.' Using large cardboard fruit carton boxes discarded by supermarkets, Mark cuts two mirror-image shapes from the boxes and then presses

'I love the whole thing, the different processes, especially the soda firing, the flame kiln, the gas kiln, building the gas kiln. I'm very much a maker, I love building kilns as well as firing.'

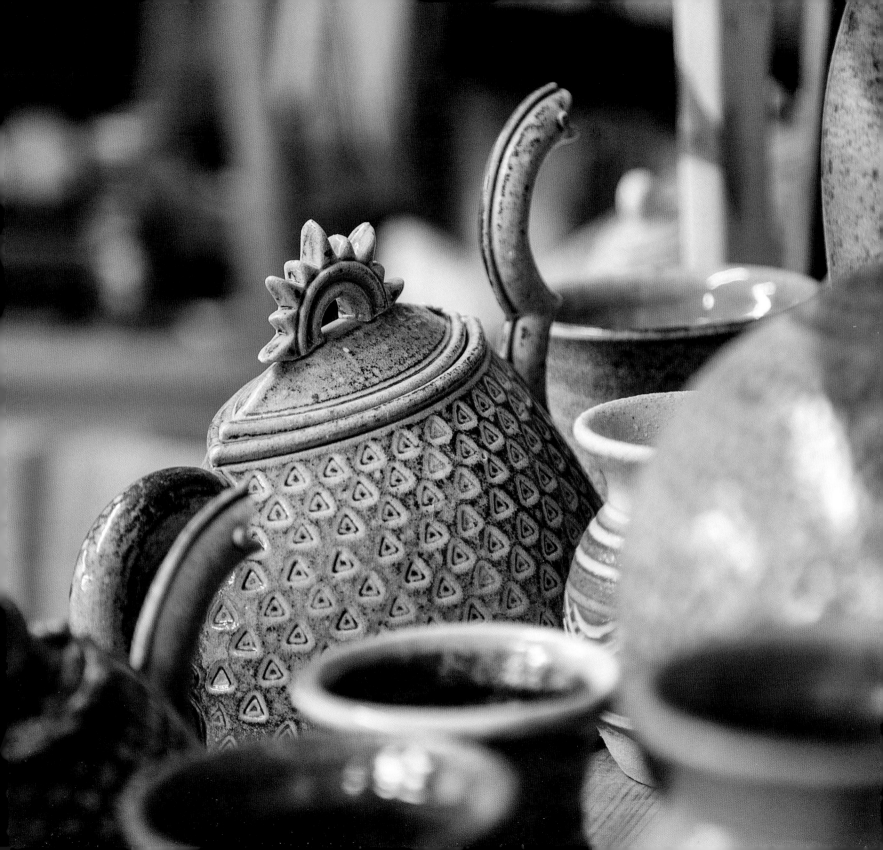

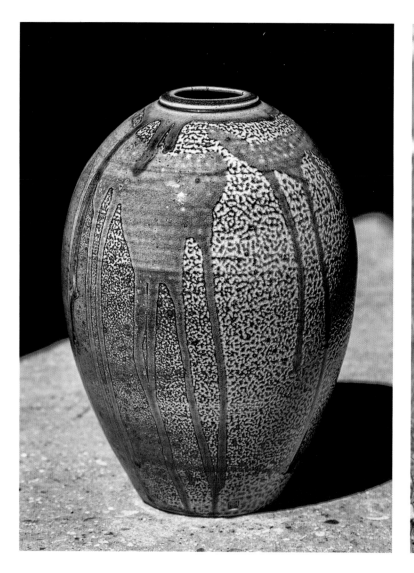

a flat sheet of clay through the hole to make each half of the jug. The two halves are carefully joined together. He then cuts the base from a semi-ellipse, a sort of semi-circle, to generate the rocking quality and then joins the new base onto the body. Lastly he adds the handle and the spout to the jug, and finally there is some careful finishing off; some smoothing, and some little decorations and finishing pieces are joined on.

His depth of immersion in the pottery tradition is evident as he comments that 'the spout part of the jug, if you go to Stoke on Trent, they'll tell you the correct name for the spout of a jug is actually a snip'. Mark loves the endless variety of shapes that are possible from this form of making: 'you can simply go and get another cardboard box and cut another shape – if you don't like the shape you've made.'

'The mottled effect, the orange peel effect as it's often called, occurs naturally.'

wood-fired kiln in Hertfordshire. Being in Milton Keynes is 'a good place to work', with a transport network providing easy access to galleries in London, York or Manchester to sell pieces, and not least because 'everyone knows where it is!' He would love to see a gallery in Milton Keynes selling 3D work and studio ceramics from local and national artists.

Selling work and generating an income from pottery has been a long-time challenge. Over the years Mark has had to balance immersion in pottery with teaching and carpentry to keep things going, not always being able to spend his time as he would like to develop his ideas and focus on his own work. He is now relishing the opportunity of generating a new body of work from the soda kiln.

Like many other potters Mark is generous with his time when it comes to sharing his skills and expertise. He offers workshops at his studio and continues to teach through evening classes. In the future he thinks that it is important to support the Milton Keynes community of potters through the provision of ceramics master classes at Westbury Arts Centre. 'To invite practitioners of their crafts in to do talks and demonstrations. To provide the opportunity to see a bit more and learn a bit more.'

A 'fire and flame person' who loves making, Mark's attention to detail and love for this form of work show through in his integration of shape, form and colour.

Mark enjoys being part of the Westbury Arts Centre community of artists, and the opportunity that this provides to work with a fellow potter on the soda kiln and providing Raku pottery workshops. He reflects that many potters work alone but the support from other artists helps to keep him motivated. He has wider pottery contacts with the Dacorum and Chiltern Potters Guild and is about to help to pack and fire their communal

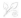

www.markcomptonceramics.co.uk

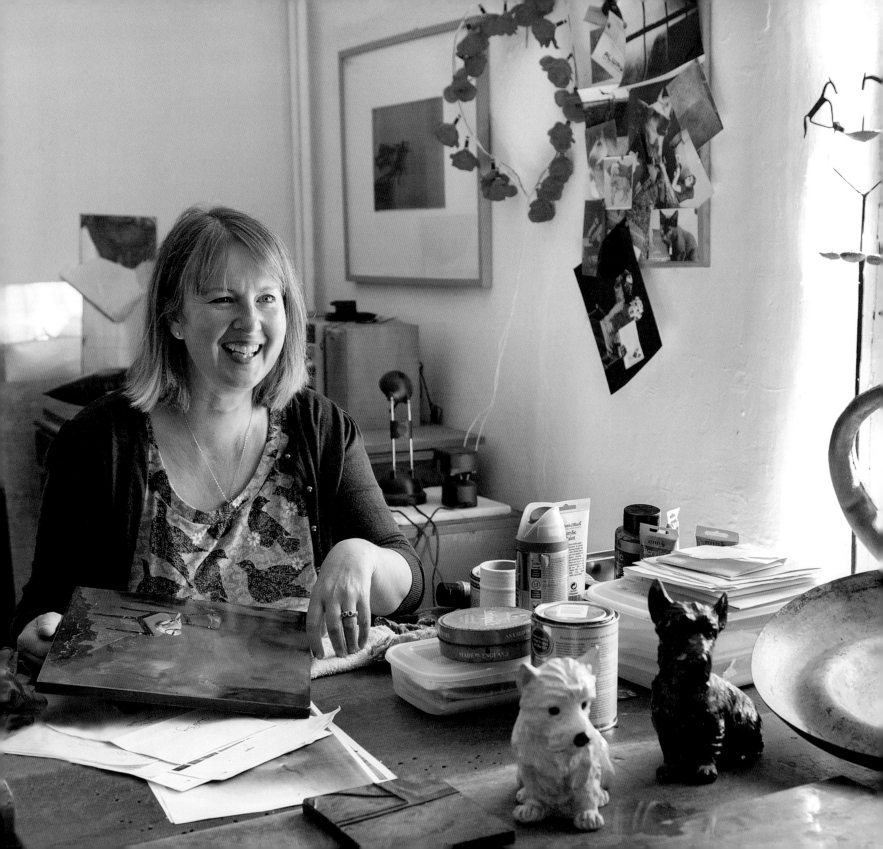

Silversmithing skills are worked large in Kate's metal canvases, generating a world of beauty, mystery and possibility. Delicate birds and flowers fly over the top of metal with a tortoiseshell patina; engraving and gilding weave detail into the stories being told. These low relief pieces transform copper, zinc, brass, gold and silver into a landscape for the imagination.

Coming from a creative family, Kate always knew that she wanted to be an artist. Initially thinking that she would become a painter or illustrator, she went to art college and 'fell' into metalwork. She discovered that silversmithing did not have to mean jewellery: 'The fact that you could treat a massive piece of metal and do intricate things with it, I thought it was fantastic.' Over the last thirty years she has continued to work with her medium using the techniques of silversmithing on a large scale. For Kate being an artist is a way of life and a way of being; a way of expressing ideas and thoughts. Her art is a 'labour of love' but also something that she has no choice but to do.

A member of Westbury since the early days in the 1990s when it was an independent, artist-led studio group Kate returned to Westbury Arts Centre some years ago. She reflects on the changes that the growth of Milton Keynes around the old farmhouse have brought:

> When we first had this house, this studio space, there was nothing round here at all, it was all just fields. So there were no shops, less houses, less of everything. So when you came it was a really

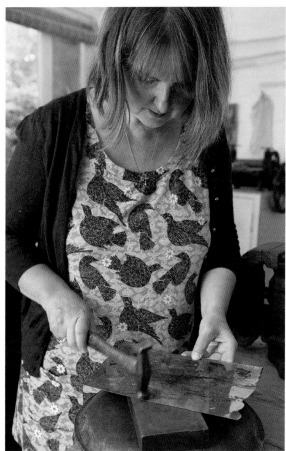

obvious building because it seemed like this big old house in the middle of nowhere. But now it's invisible. Which is quite strange in, not very long, twenty-five years or something, this area has changed so much.

She appreciates her current studio, in the oldest part of the house. Entering through an old wooden door with an old-fashioned iron latch, it has a peaceful feel about it with the old windows looking out over the wilder part of the garden. She is an outdoors person and often walks in nearby Shenley Wood. These calming spaces provide creative ideas; photographs from a bluebell woods capturing the shape of a tree branch or space to reflect on an imaginary world conjured by literature and art.

During her career Kate's work has changed, not only due to new ideas. All her early work was hand hammered:

> I used to be able to do about six hours a day hammering, planishing, texturing, chasing, for twenty years or something. And so now my body says 'I don't think so'. I can still do a lot of hammer work, but definitely not in that way. So I think that meant that the work had to change.

The painting, patina and engraving techniques that Kate has always used have now come delicately to the fore – an accidental hammer mark now is 'quite a disaster' – it needs to be a 'conscious choice to put the mark in'.

Kate paints the surface of the copper or brass metal sheets with copper nitrate before setting fire to it to generate the 'tortoise shell' effect: 'If you heat it too much then your colour changes dramatically.' She then engraves and gilds specific sections. She might also add other layers, collage or painted paper, and then these are floated into layers of lacquer. The pieces are built up layer by layer and although Kate has a clear plan she considers each carefully: 'You have quite a lot of control. Equally, it's all the

'If you've been working with metal for such a long time, you just sort of know it, and know what it will do for you.'

> 'I did a whole series to do with birds; the idea of a bird being trapped inside the space, it's maybe inside, but maybe it isn't.'

accidents that make it more interesting. Water marks and things like that you can't control, and sometimes they go in your favour and sometimes they don't.' The scale of the pieces influences the number of techniques that might be used in each one: textured sections, low-level relief from repousse, engraving, or gilding. Kate uses the full range of traditional silversmith skills but adds that with the smaller pieces 'you can't go too mad, it's a balance of process and design'. If she doesn't like the way that the work is growing she can clean off the patina and start again, but she prefers not to as 'realistically you get a better patina the first time round'.

Large canvases, up to 8ft across, take several weeks or even months to complete, but Kate points out that it's really about the layers, a small intricate piece may take just as long. Whilst she works she takes photographs of the developing piece, 'I photograph every half an hour maybe, or even more'. At the end of a day's work she takes the photographs home to look at and think about. During this creative and making process 'there's quite a bit of standing and staring'.

The calm and reflective introspection of Kate's studio work is counterbalanced by her visiting lecturer role at various universities where there are a 'thousand things to do'. She finds it really interesting discussing other people's ideas and trying to facilitate their development.

Kate also organises the graduate scheme at Westbury. Every summer, two or three new graduates are offered a short residency to extend and develop their work, culminating in an exhibition each September. 'I think it's a really brilliant scheme, bringing new artists into the studios.' She adds that 'one of the things that is great about this place is that if you want to talk about your ideas, or sharing approaches, there is the option to do that. Certainly, over the years, that has been really, really important'. Kate reflects that in her own early career the support from artists at Westbury, giving advice and guidance, was 'invaluable' and that there is a continuing and expanding need for more of this type of support for all types of artists in Milton Keynes.

Continually thinking about new ideas and expanding her technique, Kate tries to go on a course every year. Or she might set herself the challenge of making something interesting that she has seen that 'breaks the rules'.

Kate's future work will continue to reflect her interests in nature and literature. Her current work draws on a favourite childhood book, *The Little Prince*, and its 'great, tragic' story. Although a new city is not what her work focuses on in an obvious way, at the moment she is 'looking at the idea of the landscape, sort of,

being set against the story of confinement and emotional freedom.' Perhaps this is also a way of connecting with the artist Gustav Klimt, another childhood favourite whose landscapes she admires.

Kate doesn't know where her ideas for visual stories really come from – 'they just do'. And it doesn't matter to her if the viewer sees all the layers. As a fine artist using a traditional set of craft skills her work continues to delight and intrigue the viewer.

✺

www.k8art.co.uk

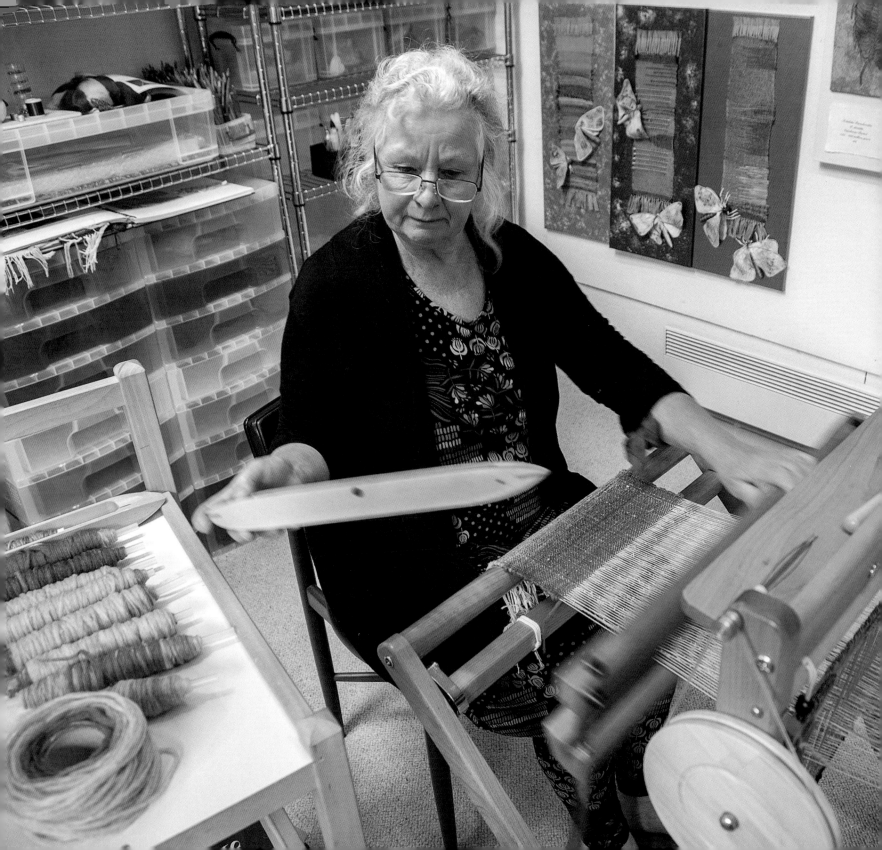

A lovely set of sounds accompanies Julienne's weaving out in her garden studio. Her loom is at the epicentre of the mix of gentle and reverberating tones. Seated in front of it, Julienne takes the various steps in the weaving process by deftly passing the weft (wound on its stick) across the warp, letting it float down and settle, before beating it firmly into place.

Julienne has several looms, selecting the most suitable for the project in hand. The eight-shaft table loom is best for the formal twill, which will form the 'his' and 'hers' scarves that are currently in progress. These two pieces are both woven on the same warp, or vertical threads, in gorgeous textured earthy colours. The 'his' version will be slightly heavier with a green thread running through it, while 'hers' will be lighter and include a hint of pink.

Her favourite loom is probably the Saori loom. This is more compact than the heddle loom and more forgiving. It is especially good for the freestyle weaving, which she enjoys most. She also has more than one circle loom, and elsewhere in the house, a tapestry loom: 'I'm kind of collecting looms,' she admits, with a chuckle. The Saori loom was used during the Bucks Open Studios sessions she hosted in her studio. Visitors were invited to select a yarn 'which speaks to you' and were tutored in how to pass the weft across the taut warp, 'beat' it down, then use their feet to alternate the two sets of warp, before passing the weft back across again. The resulting banner, collectively made by forty-four novice weavers over five days, was then awarded to one of the participants via a lucky draw. The winner got to fully enjoy

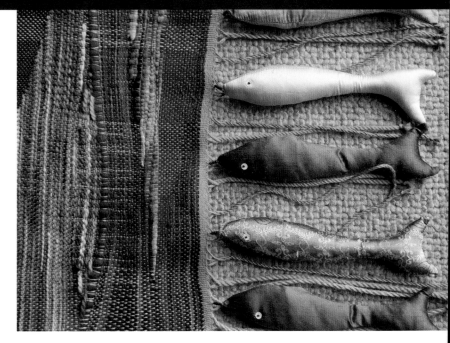

all of its rich and sparkling colours, interspersed with additional threads, locks and pieces of sari silk, and to wonder about the different personalities of those fellow weavers who had each contributed their individuality.

Since she retired from her university career, Julienne feels lucky that she is able to weave more or less every day. However, she did initially get sucked into the idea that she wanted to be 'successful' in her weaving. 'Ah, now what's success in artistic terms? Very, very tricky,' she mused. After a while Julienne managed to give up on that impulse and to 'feel much more content in my own skin, just making things for myself and to please myself.

And that's actually more of a comfortable space'. Rather than needing to make a living from her craft, something that she thinks would be very difficult, bearing in mind what people expect to pay for a piece, Julienne raises money for her local church, the thirteenth-century All Saints in Loughton, by selling her work there. 'I don't think people have a clue how much time goes into the production of a unique piece of craft or piece of art,' she comments, 'but what I charge for them doesn't represent the cost, either in materials or in the time that went into them, because if you did that you simply wouldn't sell anything'.

Milton Keynes has been Julienne's home for the past twenty-five years, so she has seen it change enormously over time. 'When we first came, I felt that it didn't have a great art culture,' she says, 'but it's sort of gradually begun to flower. There seems to be a lot more creative energy in the city than there was a few years ago.' She would like to see that being built on even more. Her immediate locale, places such as Loughton Brook and the

churchyard, have been the source of inspiration for some fairly significant pieces of artwork. 'I'm a great believer in the fact that if you want to make something artistic, you don't need to go to somewhere exotic in order to be inspired,' Julienne explains. 'I used to think that Milton Keynes wasn't a good place to be a maker but actually, the more I think about it, the better it gets,' she concludes.

As well as gaining local inspiration, Julienne also plays an active role in various networks connected with her textile art. She enjoys quilting as well as weaving, and attends summer schools, retreats and get-togethers with the British arm of the organisation Contemporary Quilt. She also met up with other yarn enthusiasts at Woolfest in Cumbria where they have everything from the live animal to the products all in one place and 'you can go and find all sorts of wonderful treasures'. Julienne is a member of international Facebook groups on circle weaving and on Saori weaving, where she can chat about the philosophy as well as the practicalities of weaving. Inspired by wanting to learn how to spin her own art yarn to individualise her weaving still further, Julienne recently signed up for an eight-module online spinning course called 'Journey to the Golden Fleece', which is run out of New Zealand. She is enjoying connecting with her fellow 'voyagers,' sharing talk and showing each other their work. 'I haven't spun before so I'm a complete novice spinner. Some of them are much more experienced, so I'm the lowly cabin boy on this inspirational voyage,' she laughs, 'it's a nice concept, the going seeking for adventure and trying to

'It's a nice concept, the going seeking for adventure and trying to encourage people to greater self-expression and to stimulate one's artistic sensibilities a little bit.'

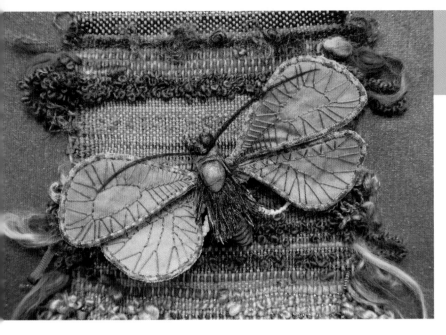

'Ah, now what's success in artistic terms? Very, very tricky.'

encourage people to greater self-expression and to stimulate one's artistic sensibilities a little bit.'

What makes Julienne happiest is if people feel comfortable with what she has produced. She distinguishes between public art, which might be designed to shock and only really be suitable to be displayed in a gallery, and domestic art, which is useful in a home setting. 'It's not necessary to shock in order to communicate,' Julienne explains. She wants her work to be suitable for a home setting: 'one of the reasons why I'm attracted to textiles is because textiles are all about increasing one's degree of comfort. Cushions, carpets, clothing.'

It's all about things that are tactile, that are warm, that are attractive and enfolding and if you make things that are all very harsh and can only sit on a wall and become art then, in a way, it's a kind of contradiction in terms. I don't think it's what I'd want to spend the rest of my time doing. Why not make things that are comforting and human?

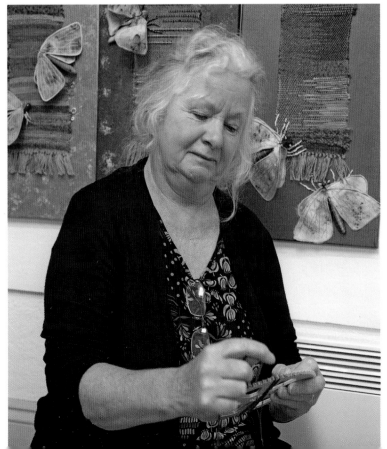

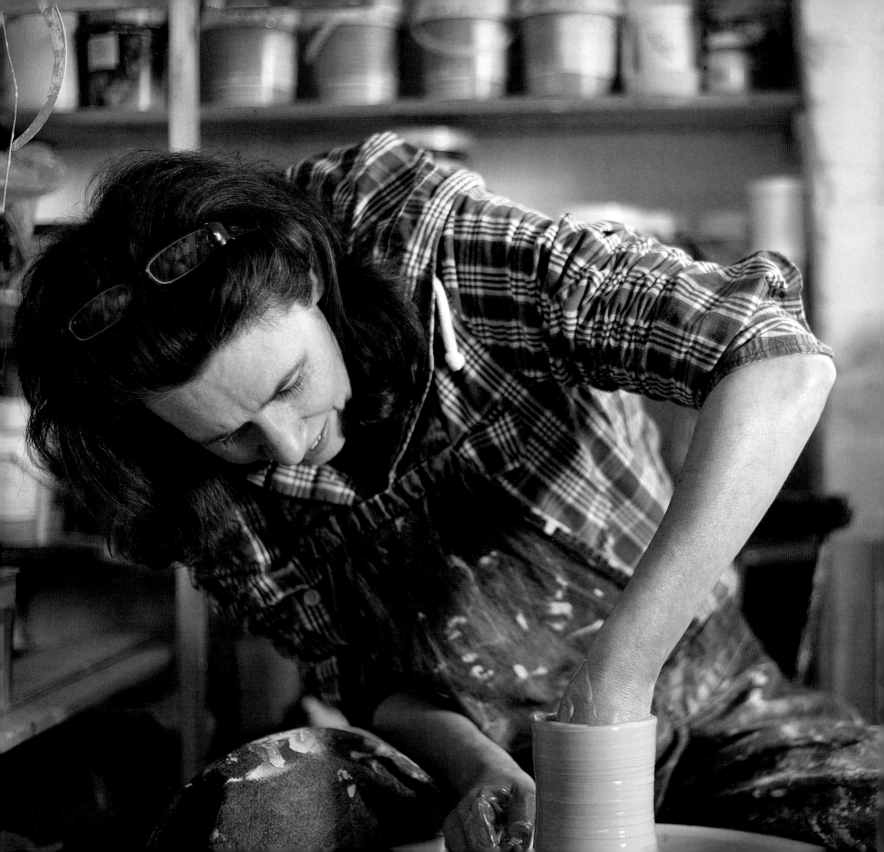

# Kirsteen Holuj

## CERAMICS

Whether it is the sculptural hand-built and coiled forms or thrown and textured pieces from the wheel, Kirsteen's work exudes a love of nature and organic forms. Incorporating gentle curves in some work and adding an edge of 'prickle' in others creates a unique collection in shades of green, white, black and natural colours. Kirsteen is currently creating work, which merges her love of texture and form with the dynamism of soda firing – an exciting new phase in her making.

Kirsteen's studio is in a generously sized room at Westbury Arts Centre which is an old farmhouse predating the development of the New Town of Milton Keynes by several centuries. Her room is in the oldest part of the building, dating from around 1670, and was originally the kitchen. The large fireplace has a couple of bread ovens on either side. There are old beams and bent walls. The stone floor is 'perfect for ceramics' and in the morning light floods in through two large windows. The room, with its light and airy feel, suits Kirsteen's work. Natural shapes, reminiscent of seed pods, nestle on the shelves and window ledges as if trying to connect to the garden where they belong. Drawing her inspiration from nature, and in particular the Isle of Coll, where her family now live, Kirsteen captures the 'wild and beautiful colours and the sea and wind and elements' in photographs to remind her of the textures and feel of the outside. She reflects that 'pod forms have always interested me. All my work, even when it was sculptural, I was still making vessels; so even the sculptural pieces still had an opening'.

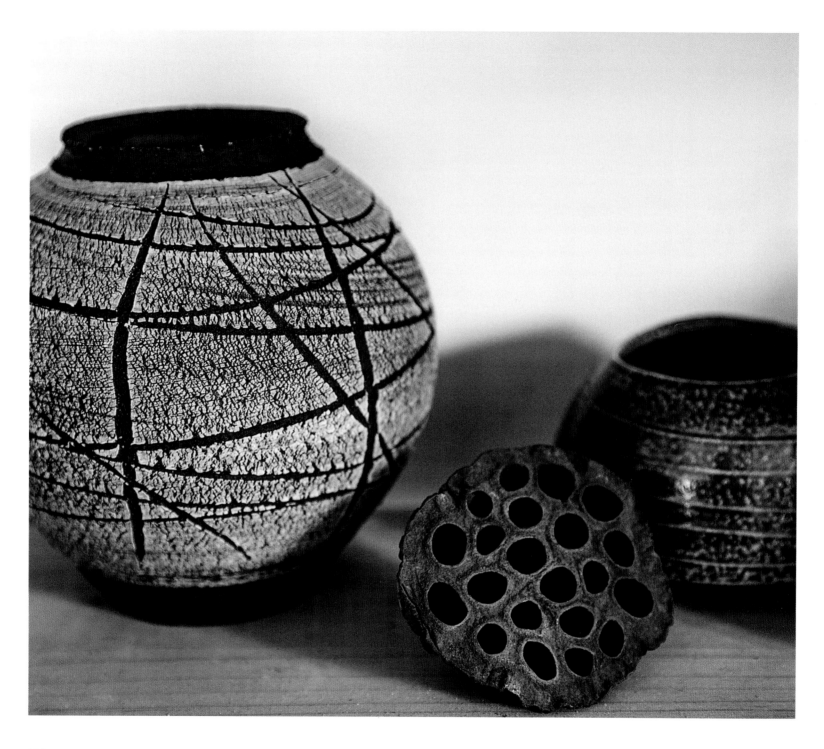

'I'm really enjoying throwing and texturing and stretching it out – which means you can't touch the outside of the surface any more. You can only touch the inside and the outside just evolves.'

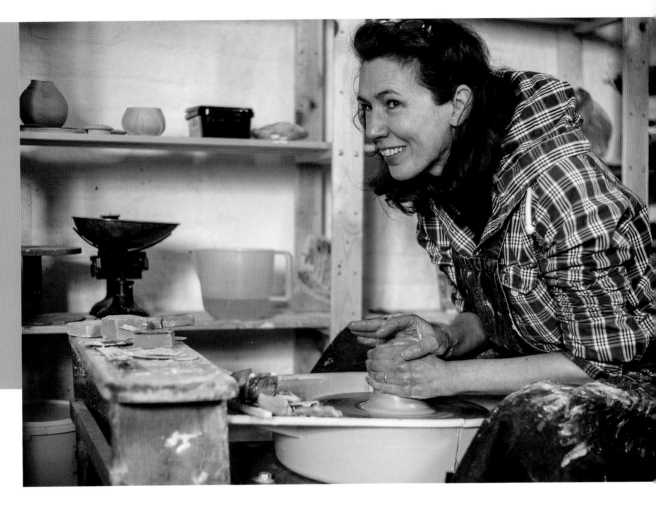

Using clay for pottery seems obvious, but Kirsteen uses up to four different types 'I wish I only used one kind of clay 'cos it would make my life much easier. But I'm a bit of a magpie – I like different clays, I like what different clays do.' So, using black clay with white porcelain, white stoneware clay for Raku firing and high-iron clay for soda firing, Kirsteen continues to explore boundless possibilities.

Manipulating the clay itself gives Kirsteen huge pleasure, whether she is coiling, making pinch pots, using moulds or throwing on the wheel:

When I'm making I love it. Then the clay's bone dry and I've already lost a little bit of interest. And then I've glazed it and I pick up a little bit of interest, and then I've moved on to the next thing to make and I'm quite happy for them to be sold and to go.

This love of immediacy, of being directly involved, is also evident in Kirsteen's expertise in Raku firing methods: 'It's probably one of the most exciting ways to fire pots.'

Raku pots are made, dried biscuit fired and glazed much like other work, but the Raku firing takes place outside in the garden

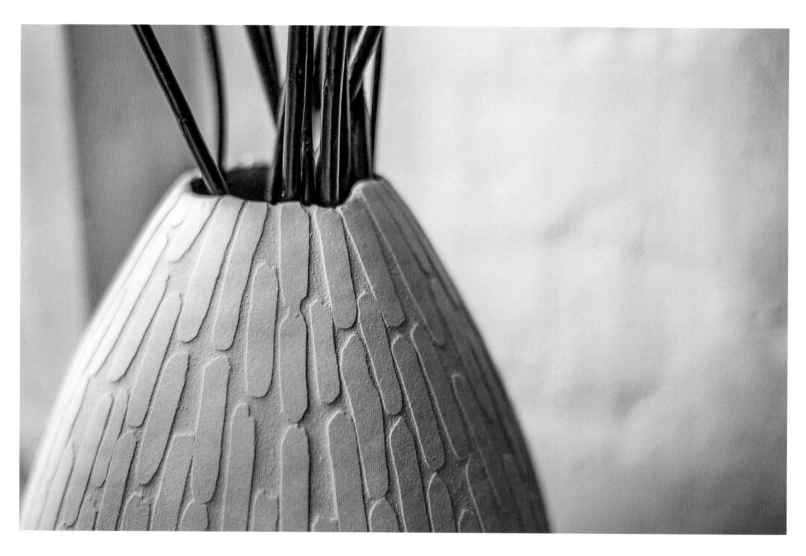

using a basic kiln with a gas burner. 'You heat it up to 1,000 degrees in about half an hour and then using tongs, and a mask and gloves, you lift out a pot – red hot, glowing.' After putting the pot into a small bin filled with sawdust which catches fire, more sawdust is added and the lid placed on the bin. This causes a process known as reduction.

Kirsteen describes the effects: 'So it reduces, it starves the pot of oxygen and you get these fantastic lustres and crackles and surprises.' After it cools, the pot is taken out of the sawdust and given a wash. Beautiful colours are revealed as the ash is cleaned off. Kirsteen's enthusiasm for this active process is clear:

You can look in the kiln and you can watch the glazes melt, and you can smell it, and you can hear it and you can feel the heat on your face, and there's a little danger element, it might burn your hands off! You're a part of it.

'I like vessels. I wanted to be a potter so I learnt to throw.'

With other new work biscuit fired and waiting to go into the soda kiln, Kirsteen is busy preparing for Bucks Open Studios and a show at Town Farm, Cheddington, in the autumn. Running a business, selling, approaching galleries with her work is perhaps the most challenging aspect of her life as a potter. She is currently reinvigorating her website and thinking, somewhat ironically, about establishing her 'brand'. These things are necessary though, as she appreciates that the people who are potential buyers are important to her, both financially and practically, as 'that moves work out of the studio, which means more work can be made'.

Already having an Interior Design degree, Kirsteen first 'touched clay' at Lill Street Art Centre when she lived in Chicago. After returning to the UK, she nurtured her interest with evening classes and classes in sculptural ceramics. She says that everything else she has learnt has been by talking to people, watching YouTube, going to exhibitions and experimentation. She follows the work of other potters and a current favourite is Patricia Shown, but that top spot is almost certain to change. She describes herself as 'like a sponge, you just soak it up really and it just comes out in whatever way it does'.

Kirsteen has been teaching ceramics classes in Milton Keynes since 2002 when she provided holiday cover for just two weeks that soon turned into a class of her own. She enjoys teaching and is inspired by the joy of discovery in her pupils. At Westbury Arts Centre she has initiated children's clay workshops, runs Raku workshop days jointly with Mark Compton and ran a local 'Pottery Throw Down' event. *The Great Pottery Throw Down* BBC TV series was good publicity for the craft, giving pottery a higher public profile, which has meant that classes are full. Being well connected to the local potters' network is important and the network includes former pupils of hers who are now making their own studio pottery. Kirsteen would like to gather the local group together more often. She describes most potters as 'very sharing' of new ideas, glaze recipes and how they do things. She has benefited from this generosity and is generous in turn.

So what of the future? More workshops and teaching because students give back energy and ideas. More exhibitions and hopefully developing Westbury to provide more space for artists and potters to show their work. And for herself? 'My dream is to have a beautiful studio on the Isle of Skye. As Milton Keynes goes it's a bit too flat for me, a bit too rigid. I love the sea, I love mountains and all that.'

Wherever she is, Kirsteen will continue to find inspiration through experimenting with the dynamics of clays, glazes and firing that bring such energy to her work.

www.kirsteenholuj.co.uk

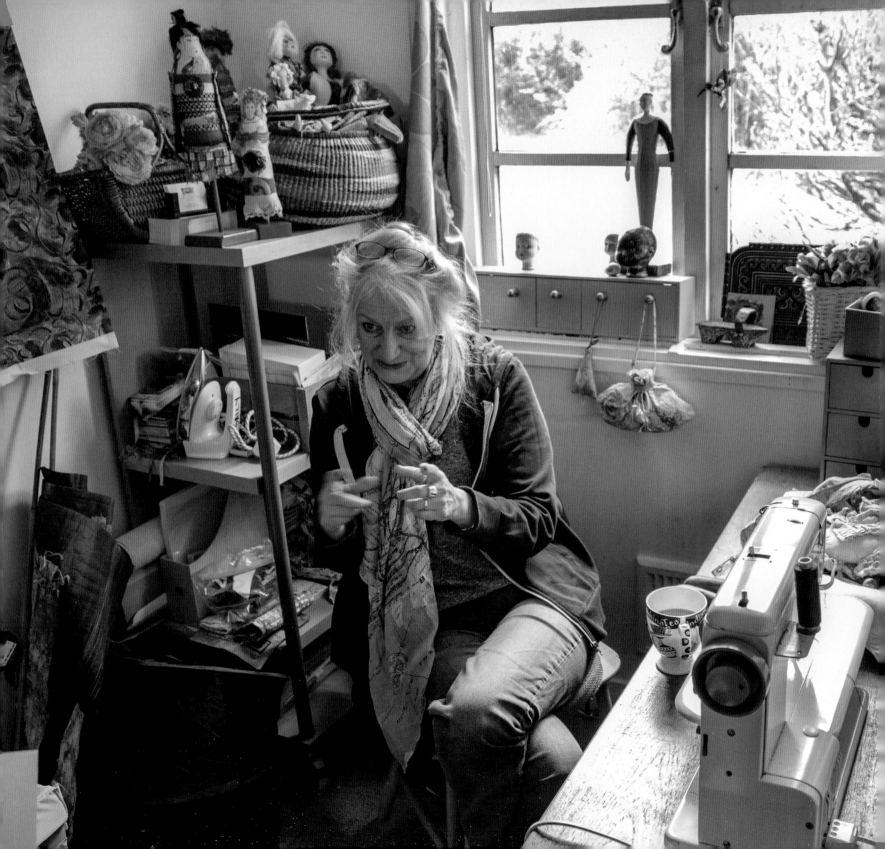

S ally's contemporary art quilts travel all around the world and her weird and wonderful art dolls are decorative collectors' items. Using her own dyed cloth and fabric designs, vintage textiles and free-motion embroidery techniques she creates 'one off' textile pieces that are richly layered and decorated. Her work ranges from small dolls to large wall hangings, from wearable jackets to art quilts.

Sally works on an old 'Bernina' sewing machine that she bought back in the 1960s with money inherited from her grandfather: 'It cost an absolute fortune at the time.' Although she has newer versions, this one 'really can do the most incredible things'. She uses the 'free motion' embroidery technique when making her quilts and wall hangings where she adapts the machine to move in all sorts of directions to decorate the work. She often creates her own materials because she loves 'getting my hands dirty and messy with dying fabrics' and through the use of applique and patches overlays the material 'so that it creates that kind of painterly feel to the fabrics'.

Sally also makes art dolls from cloth, fabrics and sometimes paper clay, which turns into a very hard, tough material. She has recently developed a new method for making the heads and bodies of the dolls. Taking calico, she waxes over the top of acrylic paints applied to the surface. The head or limbs are then burnished and polished so that it becomes hard, with the look and feel of leather. Hair might be recycled from a broken antique doll damaged beyond restoration, fabric strands or yarn. Sally dresses the dolls and other magical creatures in clothes created

from carefully chosen fabrics, sometimes worn vintage material or an old doily from a dressing table.

More recently she has been experimenting with 'Paste Grain' papers. Flour and water are mixed, colour pigment is then added and then the mixture spread on paper in layers. Marks are made to drag some of the different layers away, revealing the colours underneath. When the paper is dry it can be photographed, scanned and printed out onto fabric – creating a unique piece. Sally has also used Photoshop to manipulate images to print onto fabrics. She reflects that using the computer to experiment is 'great fun and you can spend hours whiling away the time on it,

but it's not something I always want to do'. For Sally, the computer is a tool rather than a source for her ideas.

With a love of colour and a diverse range of created items, Sally tends to have three or four pieces in the making at the same time. She loves antiques and has a 'huge collection of antique fabrics and costumes'. She has an extensive knowledge about the history of textiles and taught in that area at Milton Keynes College for many years. Her love for design and pattern is evident in her highly decorative work, which often has a sense of quirkiness and fun about it.

Although they may not be obvious, Sally does work with specific themes or areas of focus in her work, particularly for the quilts and wall hangings. Over the last few years she has tended to feature faces and figures, a phase initiated by taking a photograph of a wooden figure in her garden. More recently she has been exploring the issue of memories and memory loss.

Not necessarily Alzheimer's, or dementia, anything like that. But just, as we get older we start to lose some of the things that we've known over the years. The simple things where, you know, you muddle up the names of your son and daughter, you do the things that your Mum was doing years ago, and now you're kind of doing it. It's just a normal age thing; it's nothing wrong, it just happens. But it's those faded memories that I've started to look at in these pieces of work.

'A lot of my work actually includes antique or vintage textiles. I'm very careful with what I do include, because I don't want to go and tear up something that historically has a high value or is important.'

Like many other textile artists Sally began making clothes for dolls as a child, but her interest and love for fabrics was fixed after completing a City and Guilds with Jan Beaney and Jean Littlejohn, two 'greats' in the embroidery world. From that time Sally made work for sale and exhibitions, initially alongside running a pub and restaurant with her husband. Later, after moving to Milton Keynes and teaching 3D design at Milton Keynes College, she completed an MA in Textiles and Anthropology at the University of Bedfordshire. She is passionate about the need for students to have first-hand experience of the commercial world and says that taking her own work in and running a business alongside her teaching role 'was a really good way of getting students to learn how to run their own business and to produce their own work to make to sell or to exhibit'.

'I paint the surface of the calico with acrylic paints and then wax over the top of it.'

Now retired, Sally is currently occupying a 'floating' studio at Westbury Arts Centre. These studios are available for nine months of the year for artists to test out the affordability and their appetite for running their own studio. Sally found that after being able to talk 'art' all the time with Milton Keynes College colleagues, making at home was rather quiet. Coming here was 'brilliant, we talk about other stuff as well, but we do talk about it'. The studio helps her to think and to concentrate on developing the work away from domestic distractions. Although clear that minimalism is 'not my thing', she is currently working on pieces that are pared down and with less colour, enjoying this opportunity to explore a new direction.

Sally belongs to the Embroiderers Guild, and the Contemporary Quilters Guild in the UK. She exhibits her work at the Mall Gallery with the Society of Designer Craftsmen in London and currently has an exhibition piece with the Studio Art Quilt Associates Group, *Reading Matter*, which has been on tour for two years across the USA and Europe. She will see the piece again in November 2016.

Having pieces travelling around the world amazes her: 'Wow! How did I manage to get there? From making Barbie clothes!' But some of the most rewarding pieces that she has made have been the wedding quilts that she has made for family and friends.

www.stitchywoowoo.co.uk

# Judit Acsai

## TEXTILES AND SHOES

The computer plays a major part in Judit's design work. She tends to create a design in Adobe Illustrator, which then gets zapped over to a linked cutting machine where the design gets cut out in vinyl, ready to be ironed on to the fabric. 'It's really handy,' she explains, 'on the computer you can design something and you can see how it looks before you actually make it'.

Even Judit's embroidery is high-tech: 'I just programme it and the sewing machine does it exactly.' She feels that it is important these days to have the skills to make use of computers in her textile work. To build her skills she attended training at Arts Central run by George Hart, one of the artists who is based there. She also has a look on YouTube to see how things are done too.

Judit has only recently taken up studio space in Clyde House, in Oldbrook, one of Arts Central's newest temporary bases and travels in from her home in Northampton every day. She chose Clyde House over Norfolk House, Arts Central's other base, as she has had the opportunity of setting up in a large, semi-enclosed space, with a very stylish 'boardroom' next door, which she plans to use to teach classes. She is looking forward to a few more artists moving in there soon, adding to the six already

in residence, as the site gets established. She is just starting to get to know other artists locally and is hoping that the young and growing population of the city will provide her with students for her classes. 'Milton Keynes is a great place and I would like to stay here,' she confirms.

Her orderly studio is decorated with some of the pieces she has made recently. She loves making shoes; a pair of vivid blue espadrilles is currently under construction, stretched out with colourful pins onto a board and looking like an abstract piece of art in this early stage. The natural rope-style texture of the soles of the espadrilles contrasts with the smooth leather of the uppers, accented by bright, shiny circles of metal and playful heart shapes.

> 'It's really handy as on the computer you can design something and you can see how it looks before you actually make it.'

In another corner, a selection of bags hangs from a coat stand. Colour and texture are the standout features of these pieces too, with the orange, black and grey triangles of a sophisticated handbag, contrasting with the jaunty blue and white stripes of a beach bag. Judit likes to use a variety of materials for the things she makes. Some of the materials, such as supple leather and the thick plastic she used for an inside pocket of a holdall, can be quite challenging to work with, and she needs a robust sewing machine with a selection of needle and foot attachments. She is particularly pleased with the black and white holdall with its hot pink lining, which she designed recently. Apart from choosing suitable materials, she also pays attention to the little details that make a difference to usability, such as little studs on the bottom to protect the bag's base and a strong zip that will last. 'I had to find just the right hardware to make sure that it's all sturdy and it's not going to break after the first use,' she explains.

As well as designing, making and selling beautiful and usable products online, Judit is also keen to pass on her skills to others. She offers classes in bag making and shoe making, usually providing the materials as well, so that her students can make the most of their learning experience. She particularly enjoyed a recent class she held for two girls, both teenagers, who had never sewn before. 'In two hours they managed to make a tote bag each and I thought that was really good,' she commented.

Although Judit can follow a commercial pattern, she always likes to incorporate a twist, such as adding an interesting collar, changing the neckline, or altering the shape of the sleeves. Explaining how she progresses from idea to finished item she says: 'I normally imagine it in my head before I start making it and that's what I focus on, I just follow that.'

Recently she has found an hour or so of meditation in the morning, usually to downloaded meditation music, really helps her to conjure up and crystallise ideas in her head. This hour of relaxed thinking actually saves her time in the end, she says. She can come straight to her studio and start working, rather than, as she did previously, sit around and wonder what to do for two hours before ideas strike.

Browsing the internet and just paying attention to what she sees around her, be it a nice pair of shoes, an interesting bird, or even just a nice button, also help to inspire her designing and making. Back in Hungary, where she was born and grew up, Judit's family are all creative. Her cousin, a celebrity fashion designer

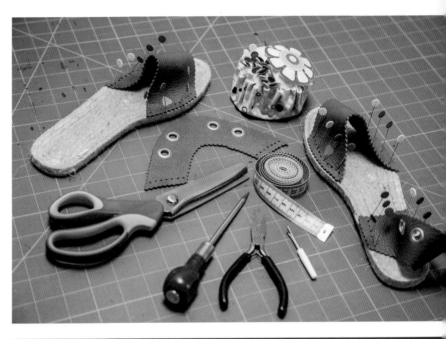

who makes 'amazing clothes', is a particular inspiration, while her father made her a wooden bed in which she slept until she was 11 years old, and her mother 'was always on the sewing machine'. This tendency to be surrounded by creative people has continued in the UK, where she has lived for ten years. Her boyfriend makes music at their home and also made the impressive thread board, which is fixed to the wall in her studio: 'It's just so much easier to go to the wall and you can see all your threads and you can choose which one is the best.' Having a studio at Clyde House has improved her home life too: 'I brought everything here, so when I go home I can just relax. Otherwise I just used to go into my room and start making something else and it's not very sociable.'

So, Judit is settled in her new studio in Clyde House now and has lots of plans for the future. She wants to recruit more students to her classes, probably by developing her marketing skills further. She would like to use her many ideas to design and print her own fabrics and has started to look into the possibilities for that. Shoemaking is also something she would like to develop. A further ambition is to one day open her own shop: 'downstairs would be my fabrics and everything I would like to sell and upstairs it would be a classroom with sewing machines set up. That's my dream.'

www.stylebyzsuzsi.com

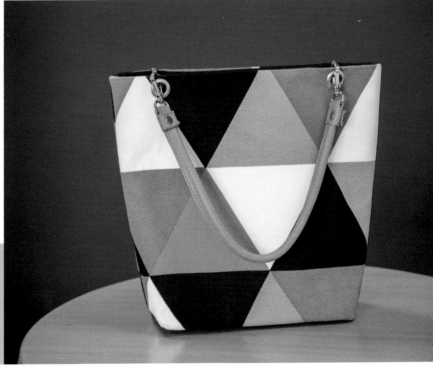

'I normally imagine it in my head before I start making it and that's what I focus on, I just follow that.'

# Louis Francis

## STONE CARVER

Louis is engaged in the most ancient and elemental craft of stone carving. Working on slate, marble, granite, newly cut and weathered stone, the simplicity of Louis's work belies the expertise required for the making. A seeker of perfection through precise clean lines, words and forms are carved onto stone to last for eternity.

At the remarkably young age of 29, Louis is a Master Craftsman. He is a Master Letter Carver, an accolade that is bestowed on members of the stone lettering community only through nomination. He is also a member of the National Association of Memorial Masons and holds specialist permissions that allow him to work within heritage sites. Louis's work goes far beyond memorial stones, although he jokes that in church cemeteries 'they look at me and think "hang on a minute, he's too young for this!"' Working on commissioned pieces and restoring old buildings, he can spend weeks on site, away from his studio space in the old barn at Westbury Arts Centre.

The studio is neat and kept clean from harmful stone dust. The extensive collection of chisels and hammers are the traditional tools used by stonemasons over the centuries. A hoist that lifts memorial stones to work at eye level is one of the few mechanical devices necessary in this craft that simply uses the hands.

The studio in the barn is ideal for Louis. He is able to move large stones and pieces in and out and he can work outside as well. 'In the summer the doors are open, the sun's shining. It's beautiful to work outside.' Milton Keynes is an excellent location, even though there are few old buildings and the font lettering chosen for some of the newer ones make him wince!

His most prestigious project so far, and one that he takes an enormous pride in, is a commission which helped to restore the grotesques of St George's chapel at Windsor Castle. The heavily eroded Victorian grotesques were themselves replacements for medieval carvings and Louis was commissioned by the Dean and the fabric advisory committee of St George's chapel to create a design and sculpt a piece fit for both the chapel's historical relevance and the twenty-first century. The piece had to be designed and carved in the traditional gargoyle form, which can

be either an animal or human. After careful consideration Louis designed and hand-carved a cobra sculpture – it now resides above the entrance to the chapel: 'It's within a prime location, you cannot miss it.' He recalls that the project took two years from start to finish, and that he created several clay models for consideration before being given the green light to carve the final piece. Adhering to strict procedures and consulting with the fabric advisory committee was challenging: 'They [the committee] were really happy with it. But I really pushed myself, because it was a big achievement for me.'

Louis's achievements are all the more remarkable, as he is profoundly deaf as a result of contracting meningitis at the age of 2. He developed a preference for art at school and during his time in the sixth form had the privilege of experimenting with stone art during a workshop run by the world-renowned sculptor Simon Cooley. Louis went on to complete an Art Foundation Course at Central Saint Martins in London and was exploring sculpture and discussing his work with his interpreter, who suggested trying out stone carving. He then enrolled on a challenging but exciting three-year course in Architectural Stone Carving at the City and Guilds of London Art School, graduating with a 2.1 diploma by 'pushing my barriers'.

> 'I feel really, really, good about it. And I love the sound of course, when I'm making something and creating something. I want to make it look perfect.'

After college Louis became a freelance stone carver. He initially worked for funeral companies and a small company engraving gravestones. 'That helped my confidence build as the quicker I got, the better I got.' As Louis continued to develop his own stone-carving style he learnt business skills from the companies he worked with – how they dealt with clients and controlled the work. Three years ago he set up his own studio and business at Westbury Arts Centre. He now meets with clients in studio and off site. Louis uses a PA telephone service, which emails any telephone enquiries directly to his inbox and an app called NGT that offers a text service via a text relay interpreter for all business enquiries and communications as well as email.

Louis and Peter Moone, his interpreter, laugh at this point as they recall phone calls and texts at odd times with Louis requesting a phone call to a client 'now, now, now' at the start. After the three years as an independent stone carver the business is really taking off, a huge achievement in this traditional occupation.

Discrimination against deaf people is still very much present in the working world, despite the Disability Discrimination Act. Louis explains that there is still a long way to go yet for disabled people to gain work equality, despite the use of advanced technology. He has had to overcome many barriers and obstacles to get to where he is today and will continue to face uncertainties as his business grows.

when the power of love overcomes the love of power, the world will know peace...

Sri Chinmoy Ghose

Having his own business means both independence and recognition for Louis's work, 'I work for myself, it's my income and my livelihood. I prefer working freelance to being employed by a company. I like to be my own boss'.

Louis often travels across neighbouring counties and sometimes further afield, to work on projects with other stonemasons and offers an express letter-cutting service for other stone industry professionals. Social media provides excellent tools for liaising, discussing and communicating with other like-minded professionals in the field. He draws a wealth of support from social media and is a member of several online stone-carving groups as well as having contacts within the deaf artists' community across the UK and Europe. He is particularly keen to support deaf artists who are doing 'fantastic work' in many areas.

Slate is Louis' favourite stone. Its simplicity lends itself well to his search for perfection in the execution of his craft. Cuts to slate need to be careful and accurate as the nature of this stone is unpredictable. Louis loves to use a 'V' indent for lettering as it demonstrates the telltale sign of handcrafted work. He is currently working on various private commissions and has exciting projects in the pipeline, one of which is a large-scale project. 'Watch this space!' he smiles.

Using expert traditional craftsmanship Louis enjoys heritage restoration alongside the creation of new work. Whatever he is working on 'simplicity and perfection' are his guiding principles.

Sign language interpreter, Peter Moone.

www.francisstonedesign.co.uk

'I depend on my hands, that's my tradition.'

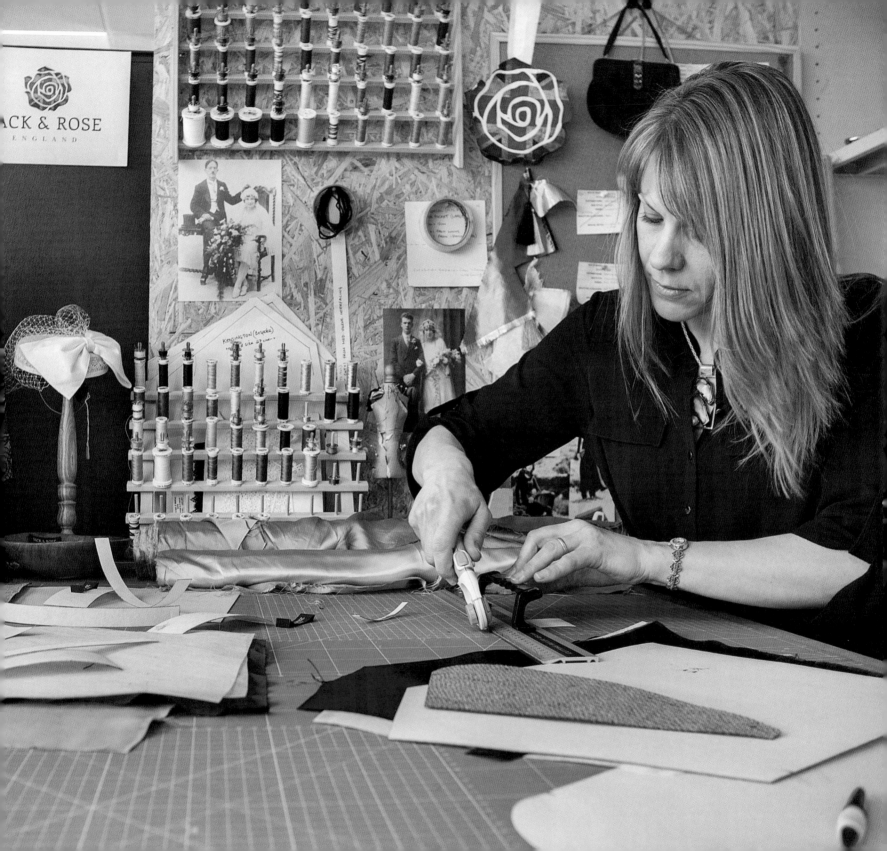

# Lisa Kinrade

## BESPOKE HANDMADE BAGS

A sense of history is the most noticeable feature of Lisa Kinrade's studio space, despite its location within one of Milton Keynes's modern office blocks. A photograph above her worktable of Jack and Rose, Lisa's grandparents, on their wedding day back in the 1920s, highlights her creative heritage, while vintage 1920s and '30s handbags gleaned from eBay hang on the wall as reminders and inspiration from a bygone age. Jack & Rose is also the brand name for Lisa's business, with the logo emphasising its roots in traditional British values.

Lisa explains how she loves the picture of Jack and Rose and likes the way it's pulling them into what she is doing today, helping her to feel that she is from a long line of creative, independent people. The bags she makes today have names such as Finchley, Camden and Kentish Town, inspired by the north London areas where her grandparents lived and worked. Lisa's Mum, Gill, has also played a part in her creative development, teaching her to use a sewing machine when she was young, and providing inspiration and partnership with her successful millinery business.

The fabrics, which Lisa uses in her bags, also combine the present with the past. Sumptuous Dupion silks have been used for centuries as a luxury textile for clothing and accessories, while today's mix of jewel colours or more muted greys and oysters bring it right up to date. Lisa also explains that the most important part of a bag is the inside. For this she likes to use high-quality materials that handle well and give the bags good shape. It is also important that the inside of a bag is suitable for the lifestyle of today's women, so it is vital that it is large enough

> 'I'd like to think that one day my bags will be vintage, they will get handed down and kept.'

to accommodate an iPhone, for example. One of the advantages of a bespoke approach is that specific needs can be addressed too, such as for the woman who needed a stylish bag that would also let her carry her medical inhaler. Cherished fabrics, such as the vintage Italian lace that Lisa was asked to incorporate into a bridal bag, can also bring another echo of the past into her bags.

Design challenges are part of day-to-day life for Lisa. She needs to balance a need for her bags to be neat and tidy, with a desire for them to be unusual and interesting. She picks up ideas from all sorts of sources – a local church doorway has been an inspiration for a particular curve in the flap of a bag that she is currently making. She also needs to be able to incorporate clients' embellishments into their bag too, while making them something unique and different. Lisa also hopes that the work she has put into their bag will be valued and that they might be handed down through the generations, stored in their special Jack & Rose boxes.

Lisa finds the artistic community at Arts Central to be a very supportive environment and enjoys the Wednesday lunchtime get-togethers of the resident artists where people chat about what they are doing. Ideas might be sparked from those conversations and collaborations have grown from meeting an artist with a different perspective. Recently, one of the other resident artists, George Hart who makes clocks, suggested that laser cutting the bag's pieces would help precision, as well as give Lisa the opportunity to try out new shapes. It is a partnership that is working well. Lisa has also found that if something about her work is niggling her, or if she is not sure about something, she can go and have a word with one of the others and ask if they can recommend a device that does this or a glue that's good for that. Much better, she said, than the feeling of isolation that can come from working alone at home, despite having a lovely studio there. The only drawback of being amongst so many creative people is that 'it's easy to get distracted as there are so many great people to talk to'.

Looking around Lisa's studio at Arts Central, everything was neat and orderly, with a little station for all the different stages of bag making. As well as the sewing machine, a computer is another essential, to meet the need for marketing, business management and social media. You have to do many things to make a small

'Everything I make is completely unique and I know there won't be another one out there.'

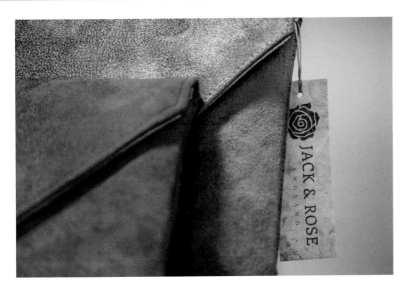

business a success, says Lisa. She also has to balance the needs of the business with her family life too. She hopes that her own striving for success will be an inspiration to her two teenaged children. They are already showing signs that they could be the next generation of creative and artistic family members with a bold approach to design, which particularly impresses Lisa.

She finds the view from her studio space out across Milton Keynes inspiring too, with the many trees changing with the season and the angular architecture of the modern buildings and the Grade II-listed shopping centre providing a backdrop. 'And it's never still out there, there's always something going on, people moving about and going about their business. I like that, I like the hub and the busyness of it.' Lisa finds Milton Keynes a great place to develop her art because 'anything progressive is inspiring and takes you along with it and anywhere there's a good buzz and a creative vibe encourages you to join in'.

The networking and chat about making doesn't stop at Milton Keynes either, with Lisa being so passionate about her bags that she is keen to talk about them wherever she goes, including on holiday. She finds she can always learn from other makers and pick up tips. The next stage will be to pass on her own skills to others, and she plans to start running skills workshops soon. She would also like to develop her own skills further by designing and printing her own fabrics, using computer packages, to make her bags even more bespoke. 'I've got loads and loads of ideas, so I just need to get those new ideas out there.'

www.jackandrosevintage.co.uk

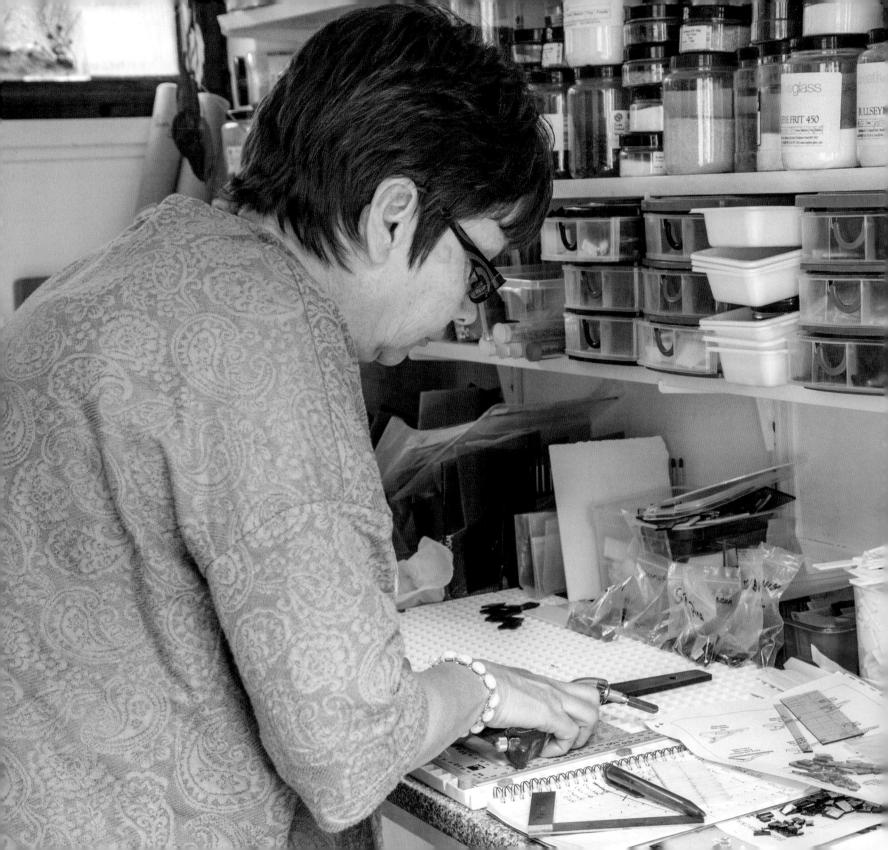

# Lynne Lane

## FUSED GLASS ARTIST

There is a lot to explore in the back garden of Lynne's modern house set in one of Milton Keynes' grid squares near Willen Lake. A kaleidoscope of interesting sights and sounds greets the visitor as they step out through the French doors from the house. Tinkling water energises the graceful pond, while a mass of plants and flowers provide contoured colour and texture. A hand-built bread oven suggests the possibility of wafting aromas, and up above young blue tits play peek-a-boo from their nesting boxes as they decide whether to chance a first flight.

The most interesting feature, however, is the inviting building that Lynne shares with her husband as they both go about their creative and constructive pursuits. Inside this compact studio space, Lynne has lined the walls with cupboards and shelves which carry all manner of intriguing-looking jars, plastic boxes and labelled sets of little drawers. Two kilns, one large, one smaller, stand business-like and ready for action, while the workbenches look well equipped with a range of sharp tools. It is easy to get carried away and forget about everyday life, she says, out here amongst the frit and 'cabs' in this well-ordered space.

Lynne describes what she makes: 'I started off making larger objects like bowls and dishes and pictures. But over time I've gone more to jewellery, smaller items. So I make anything, earrings, rings, pendants, and then at Christmas obviously there's a few Christmas decorations.' Lynne's glass art is mainly fused glass but the type of glass can vary and includes shiny dichroic glass,

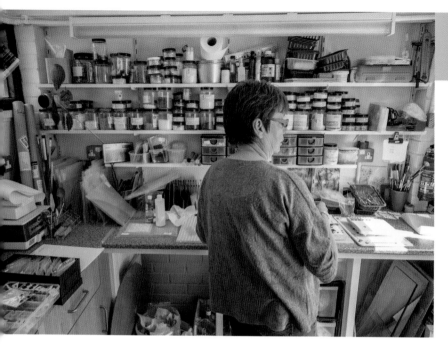

The firing temperature is a vital element of the design planning too. Mind-boggling highs of up to 800°C are used for pieces that Lynne needs to fully dome, although the slightly lower 740°C or 760°C can be useful if there is a need to retain texture. These high temperatures, with the kiln needing to warm up slowly and then cool down slowly, can play havoc with the electricity bills. However, the recently installed solar panels on the roof are helpful and can power the smaller kiln during daylight hours.

As well as being inspired by new types of glass, Lynne finds inspiration from lots of sources. Watching the sewers wrestling with zig-zags in *The Great British Sewing Bee* on television, inspired her to incorporate strong bold lines into some pieces, while a friend's architect trainee son's rock project inspired her to interpret rock structures in her work. Images of the butterflies she loves feature on several pendants, and the nearby Willen Lake and canal at the end of the road have inspired others that portray a sense of watery reflections. She says that most of those have been sold. She feels very lucky to live in Milton Keynes with its many opportunities for local nature walks and its interesting new buildings and usually takes her camera out with her: 'inspiration can be anywhere,' she confirms.

Early experience of glass art came from a taster course Lynne took at the Great Linford Arts Centre about fifteen years ago. That course was led by Amanda Moriarty, who specialises in innovative techniques using vibrant colour: 'she was very inspirational.' That was followed by another course at the Grace Barrand Design Centre in Surrey. An Arts Council grant enabled her to further develop her techniques on a week-long course at a training centre down in Kent with the American glass artist, Judith Conway. 'The more you learn the more you want to learn,'

as well as iridised glass and coloured glass to mix in. She likes to experiment too and has recently been having a go with some new red reactive glass that her suppliers have just brought out. To learn about how to make the most of it, she goes online and downloads the technical sheet. Next she checks out the recommendations for use and firing temperatures in the training section of the supplier's website and then just has a play to see what happens.

Another recent enthusiasm is the use of glass paints for design work. Lynne admits that she is not particularly good at drawing so has found a solution: 'I use stencils or outline stickers to help put the design on.' The painting might be combined with other techniques, such as in one particularly intricately layered example: 'so that started off as a piece of clear glass, then you add in the pieces of differently coloured frit to get the shadowing. Then it's fired to fuse the glass, then I've painted the design on and then re-fired it.'

Lynne observes, 'and there is so much to learn.' Motivation is also gained from the people who admire her work: 'I just like the reaction when people, if you go to a craft fair and somebody will say "ooh that's nice". That gives me pleasure.'

Lynne's glass art started out as a hobby but eventually she gave up her day job and began to build up the business. Although actually making a living out of her art is challenging, she does have a network of people that she sells to. Some selling is of completed items and others are of fired glass pieces, ready for others to finish, such as the tiny, fiddly glass cabochons or 'cabs', which can be made into earrings and cufflinks. A Belfast-based customer placed 'a very nice order' for thousands of cabs a couple of years ago: 'I was firing up the kiln twice a day, for a long time.' Another customer uses her cabs to make earrings, which she sells on Amazon, while Lynne also has an online Etsy shop.

She used to do quite a lot of craft fairs but is starting to find those less profitable these days due to increased competition and a difficult economy. It can be hard to sell some pieces for other reasons though, and thinking about one pendant she made after being inspired by a visit to a Chihuly Glass exhibition at Kew Gardens, she muses: 'I wish I hadn't sold it now, because I loved that piece.' 'It's certainly impossible to part with some pieces,' she remarks, while making a replacement isn't really an option as 'that's part of my selling, every piece is unique'.

www.lynnelane.co.uk

'The more you learn the more you want to learn, and there is so much to learn.'

# Making Art in Milton Keynes: Looking to the Future

The maker-artists' stories presented in this book show that the handcrafting of artistic objects is flourishing in Milton Keynes. In garden studios, converted garages and community arts centres, maker-artists are developing and merging the traditional and contemporary skills that give form to beautiful and purposeful three-dimensional designs.

The maker-artists speak of a fundamental need for individual expression and a deep satisfaction with the making processes that keep these skills alive. Showcasing the work of local maker-artists can support a vibrant local economy and strengthen community connections. It is therefore vital that opportunities are provided for them to display their work in galleries and community centres. Support through the provision of selling opportunities is also important for those maker-artists who wish to make a living through operation as a creative micro-enterprise.

All of the maker-artists stress the excitement of learning and teaching, whether it is gained by passing on their skills to others, or through further developing their own techniques. There is a need to keep pace with the expansion of Milton Keynes through the greater provision of opportunities for training for all types of artists. Offering the public the chance to 'have a go' at learning new skills and new ways of thinking is also vital. These activities help to enrich people's lives, developing an appreciation of the value of art and artistic skill and promoting pride in the cultural heritage and future of Milton Keynes.

The New Town setting of Milton Keynes provides people with a unique opportunity to bring in ideas from elsewhere, while putting down roots and taking inspiration from their new surroundings. As well as appreciating the stimulus of their physical surroundings, the maker-artists all speak of how much they value the support and impetus that they draw from the town's artistic and social community. The cultural hubs and arts centres are essential in enabling the wider community to participate in creative and life affirming activities. These hubs need to be supported and further developed in order to nurture these collaborations.

For the maker-artists in this book, defining themselves as artist, maker, craftsperson or perhaps more specifically as metal artist or stone carver is a matter of identity – complex and subject to change. Some makers feel that using a 'craft' category suggests being weighed down by tradition, while others embrace traditional craft-based skills and exploit what these might bring to their designs. Some makers are wary of calling themselves an 'artist', but see the label as aspirational. The use of the term maker-artist resolves this issue and acknowledges their combination of craft skills, creativity and artistic sensibility.

The twenty-five maker-artists in this book are the tip of the iceberg in Milton Keynes. Even that tip is sometimes hidden below the surface. But for those willing to look, Milton Keynes has a vibrant and growing artistic life that merges old and new and promises an exciting future.

# Further Reading

## BOOKS ON THE HISTORY OF MILTON KEYNES

Finnegan, R. *Tales of the City: A Study of Narrative and Urban Life* (Cambridge: Cambridge University Press, 1998)

Hill, M. *Milton Keynes: A History and Celebration* (Salisbury: Francis Frith Collection, 2005)

Hill, M. *Milton Keynes Then and Now* (Stroud: The History Press, 2012)

Ward, C. *New Town, Home Town: The Lessons of Experience* (London: Calouste Gulbenkian Foundation, 1993)

## MILTON KEYNES PLANNING DOCUMENTS

Milton Keynes Council (2014) 'Art and Public Art Strategy 2014–2023'. Available at: https://www.milton-keynes.gov.uk/leisure-tourism-and-culture/arts-and-heritage/arts-organisations

Milton Keynes Futures 2050 Commission (2016) '*Milton Keynes: Making a Great City Greater*'. Available at: http://www.mkfutures2050.com

## BOOKS ON MAKER ART

Livingstone, K. and Parry, L. (eds) *International Arts and Crafts* (London: V&A Publications, 2005)

MacCarthy, F. *Anarchy & Beauty: William Morris and his Legacy 1860-1960* (London: National Portrait Gallery, 2014)

Norman, J. *Handmade in Britain* (London: V&A Publications, 2012)

Sennett, R. *The Craftsman* (London: Penguin, 2008)

Treggiden, K. *Makers of East London* (London: Hoxton Mini Press, 2015)

# Index